POPCORN
ILLUSIONS

Andrew Guenther

Popcorn Illusions

Andrew Guenther

Popcorn Illusions

Artwork © 2014 Andrew Guenther

© 2014 Andrew Guenther. All rights reserved.
ISBN 978-1-304-75098-3

Contents

	Introduction	9
1	Shallow Fields	10
2	Concepts of Space on a Single Plane	16
3	The Weight and Measure of Time	36
4	Increments of Time	48
5	Evidence of Time	60
5	Spaces and the Flatness of Being	76
6	A Short Play	94
	List of Illustrations	102

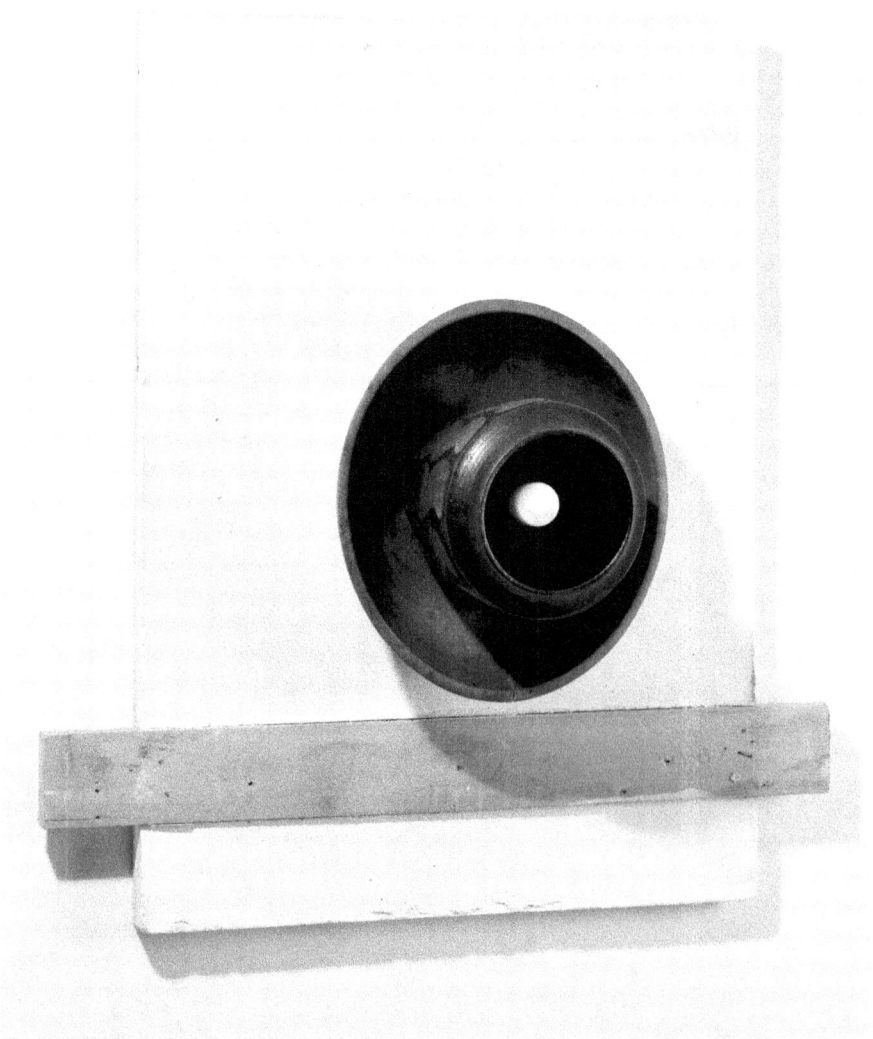

What do you consider your most misunderstood endeavor either resolved or still in conflict?

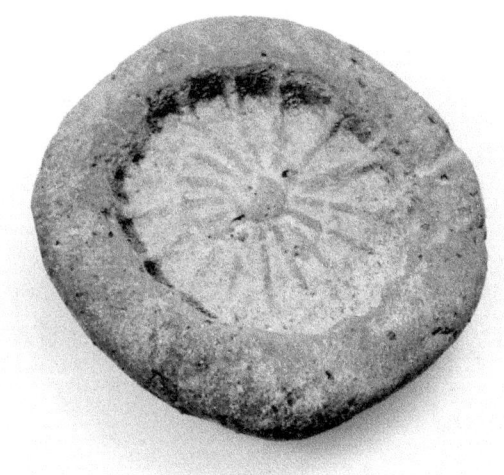
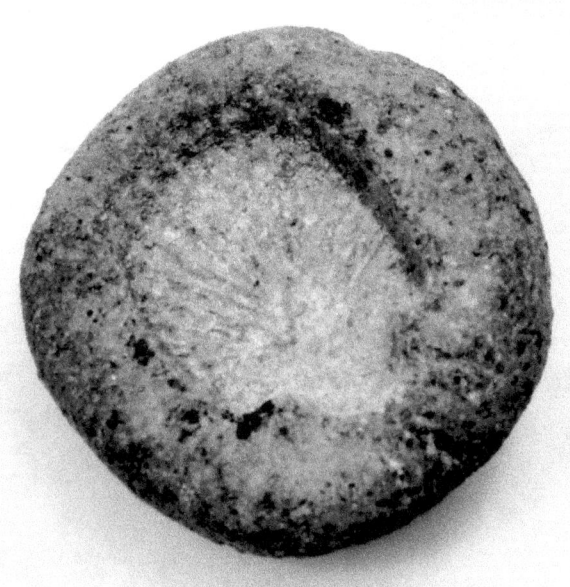

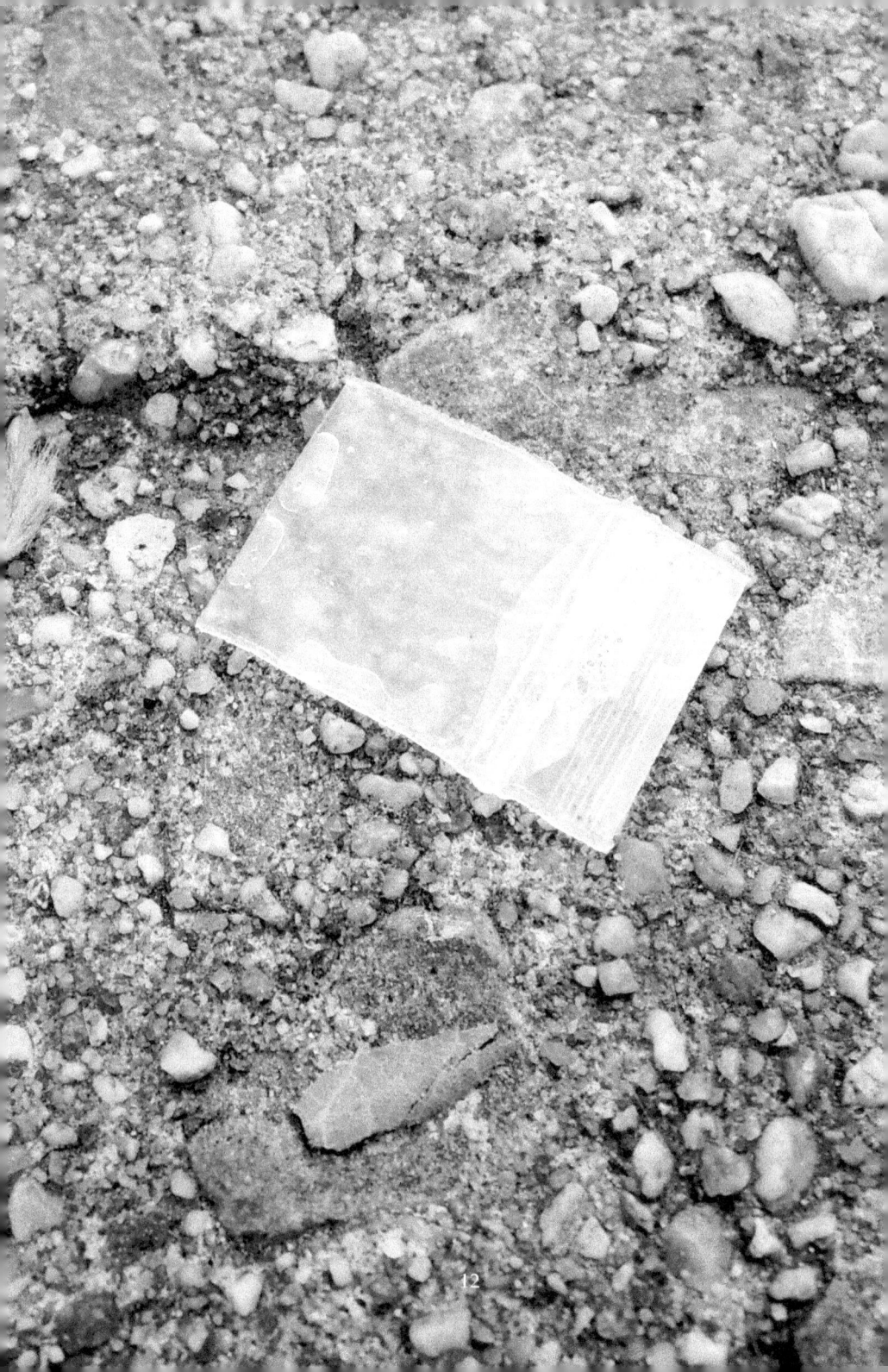

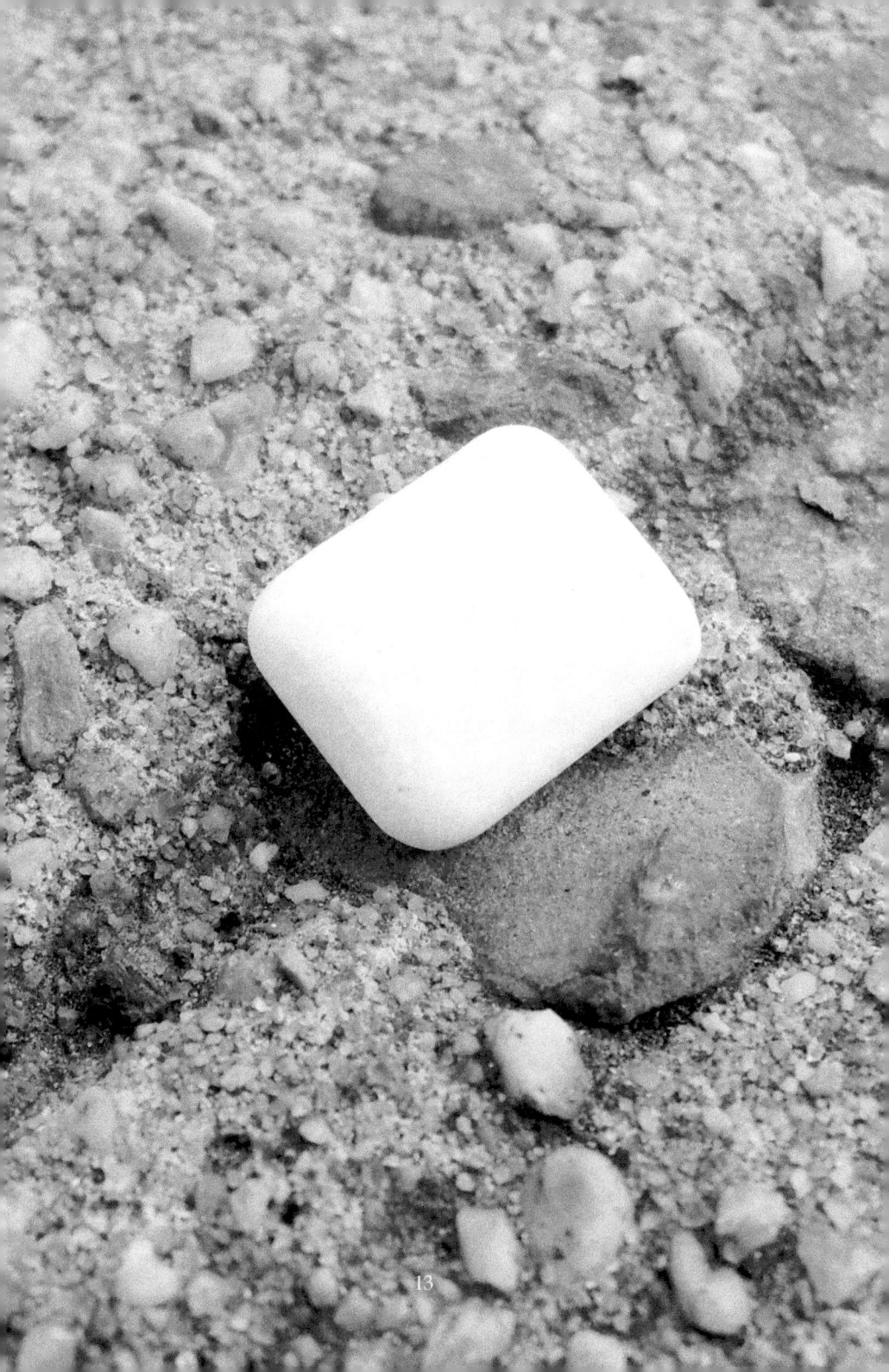

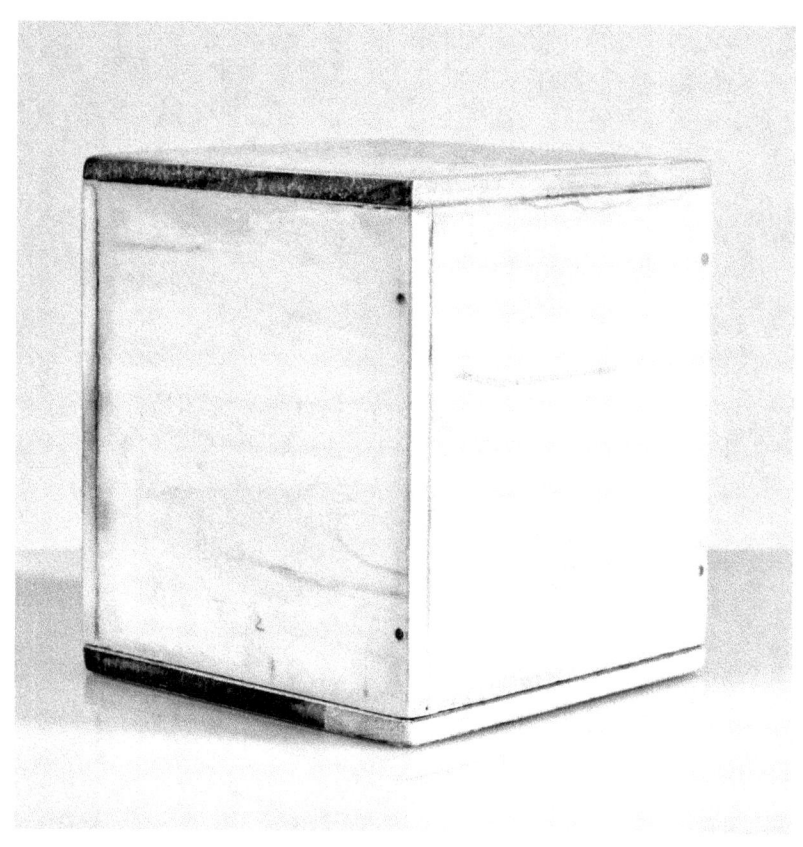

5/8 - 3/4

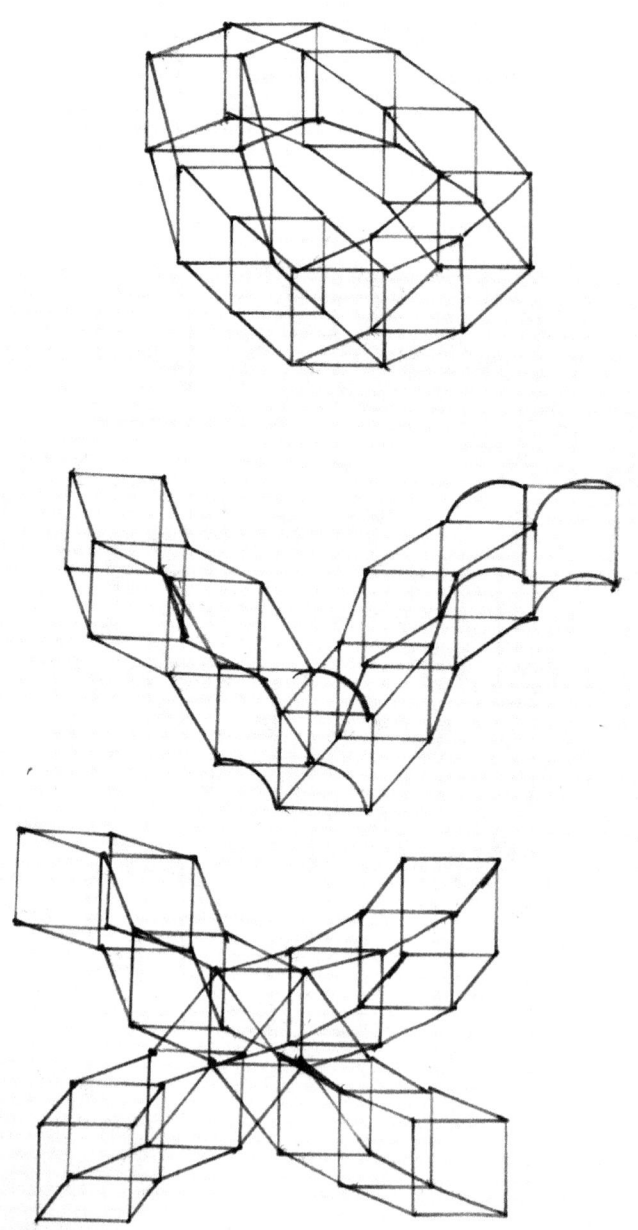

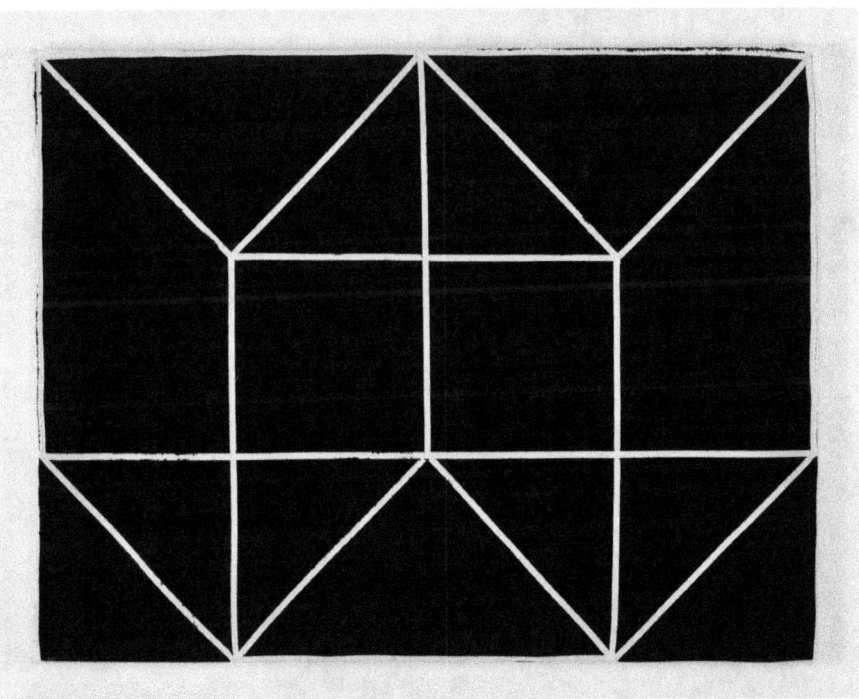

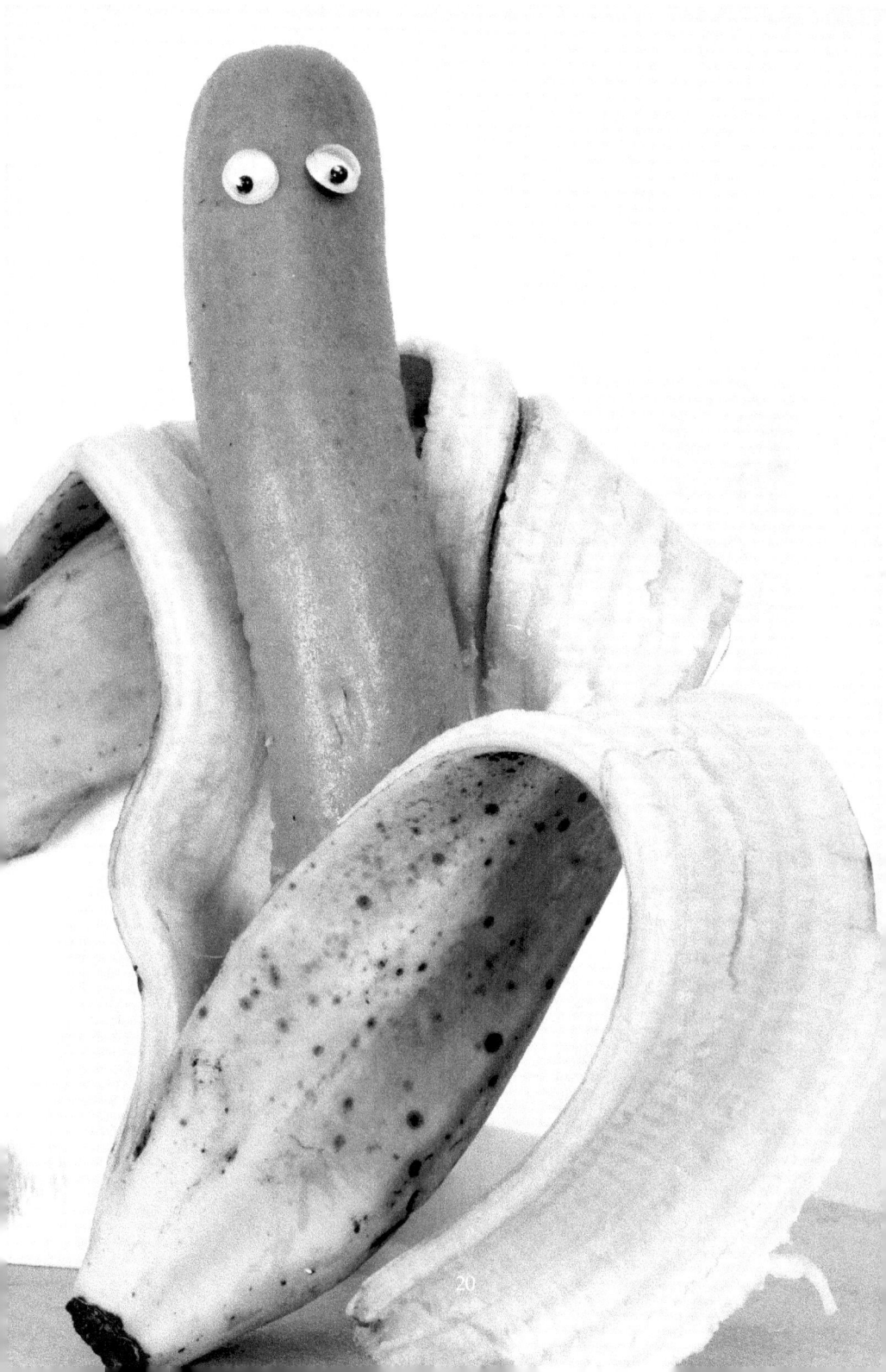

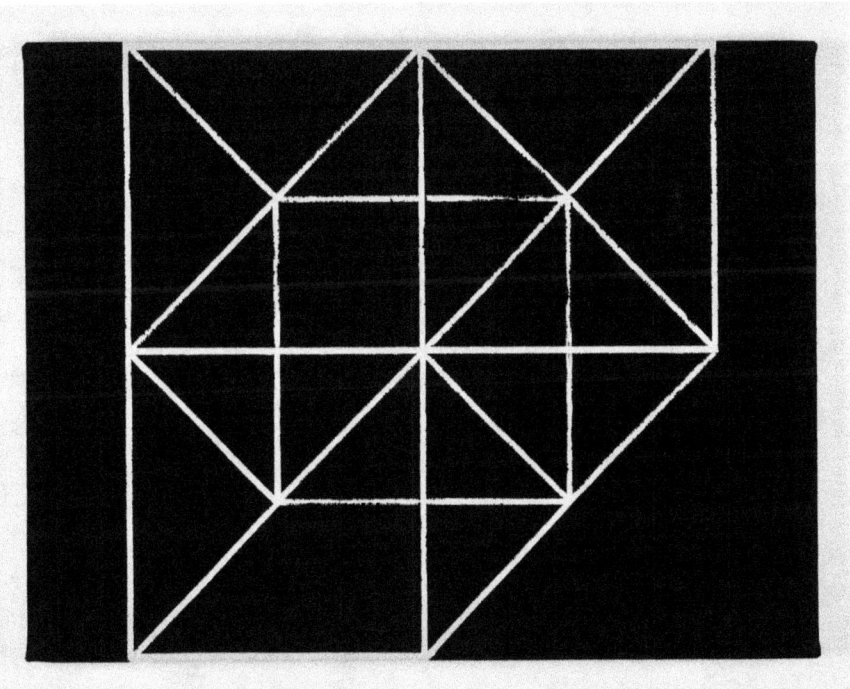

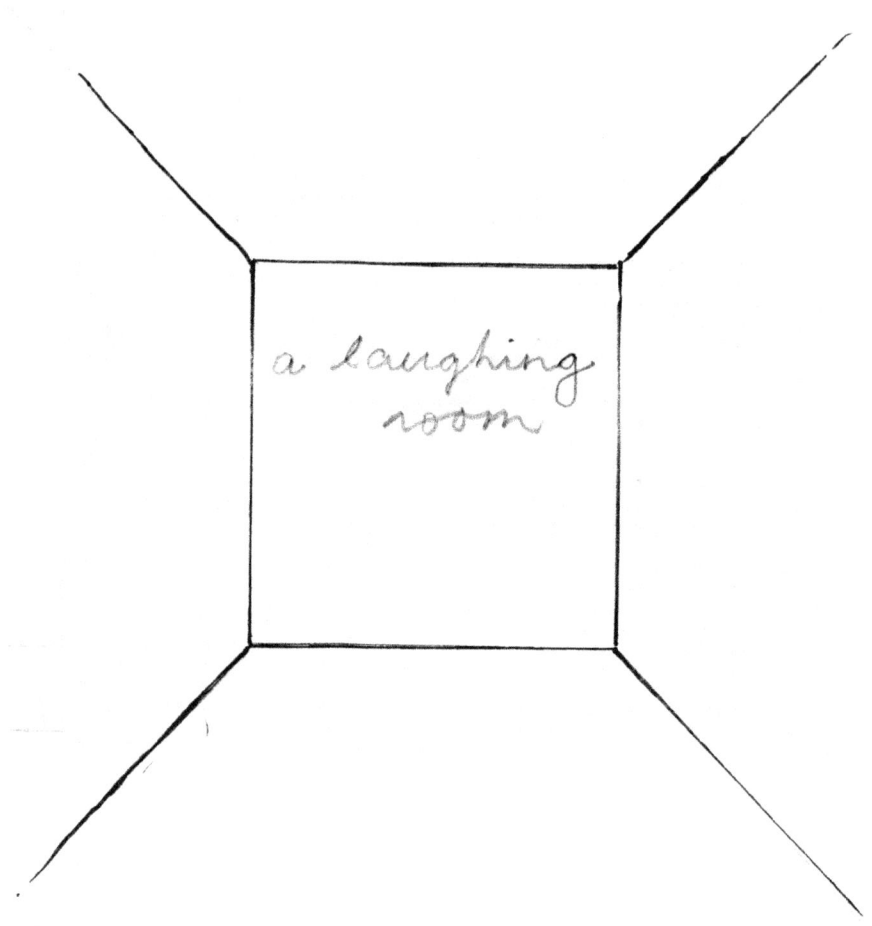

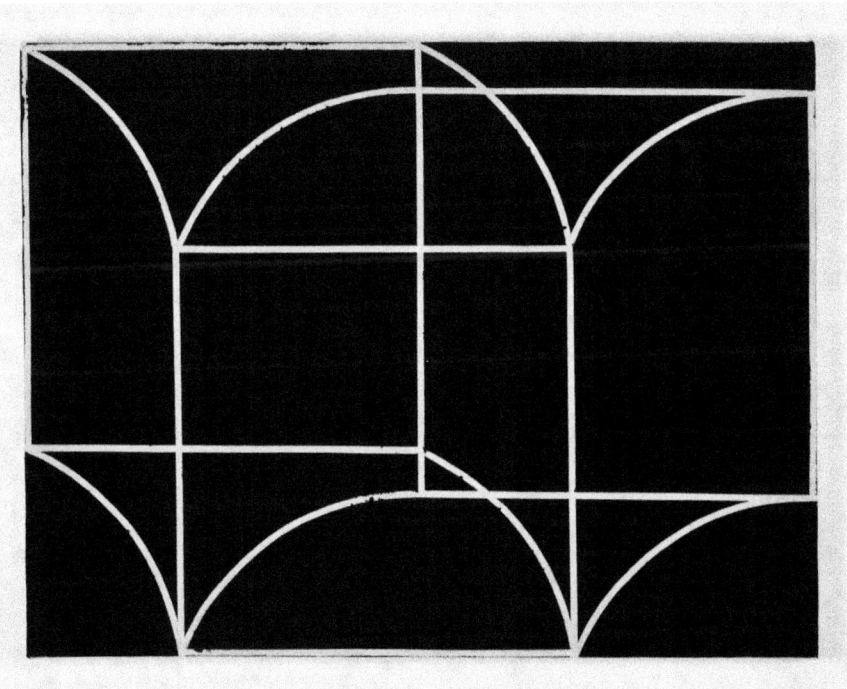

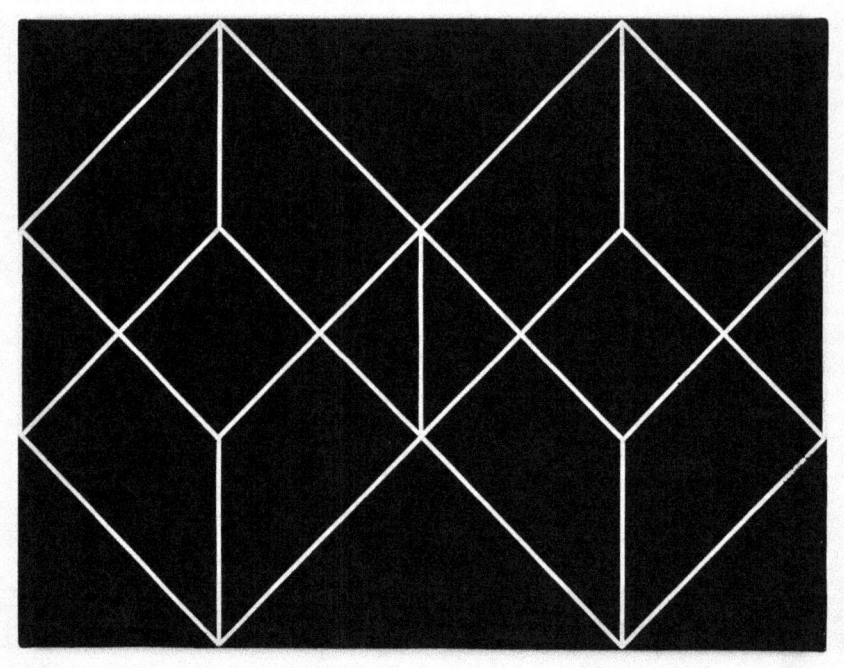

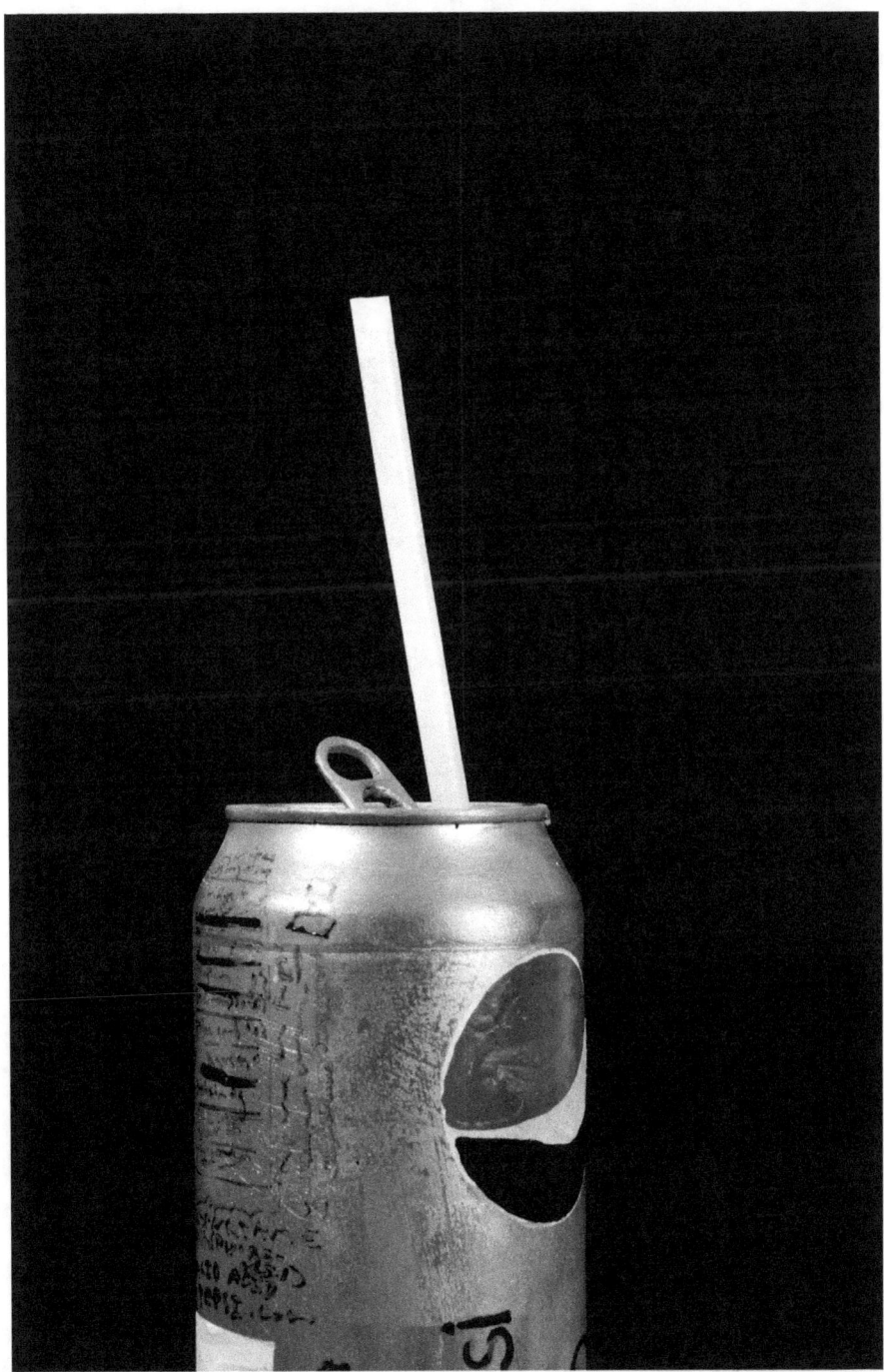

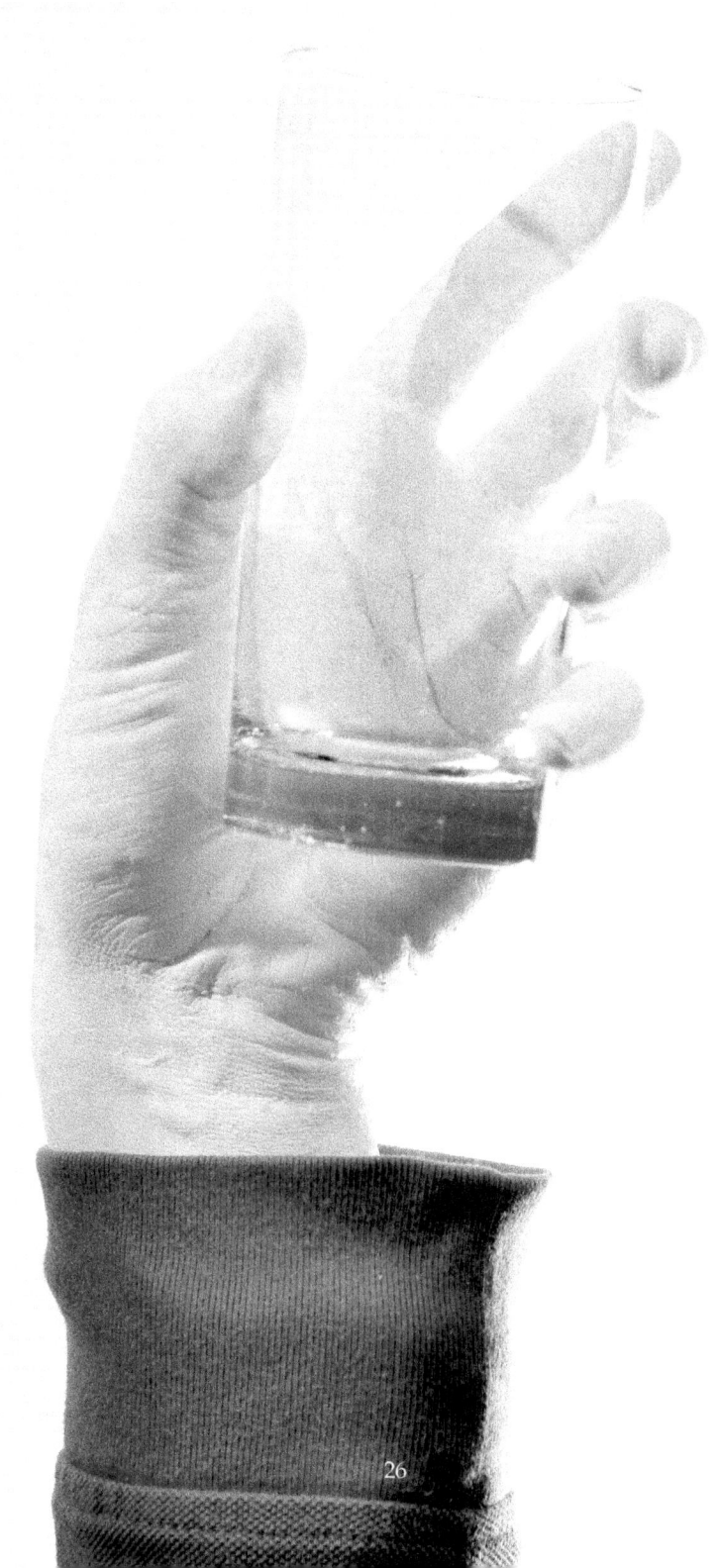

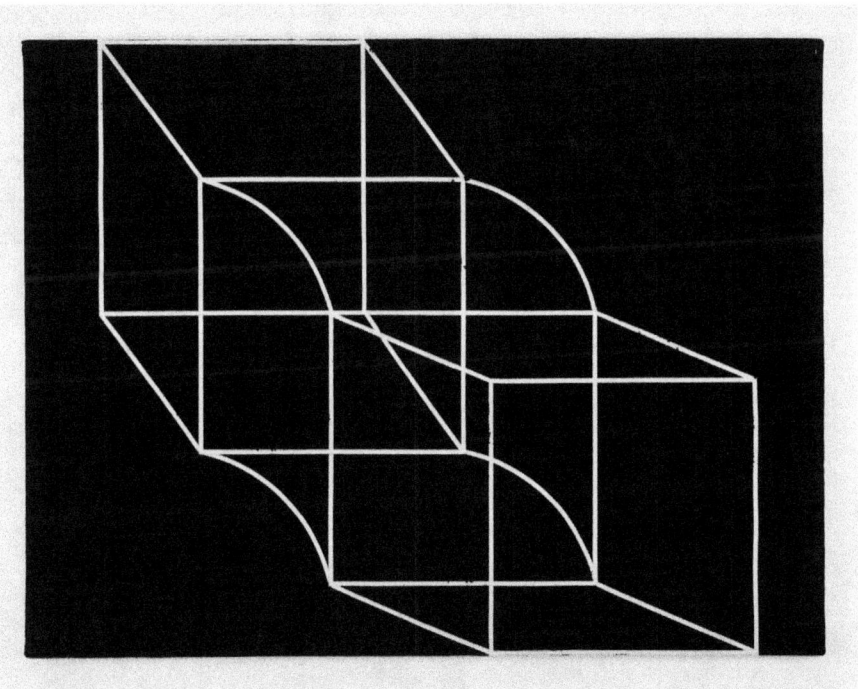

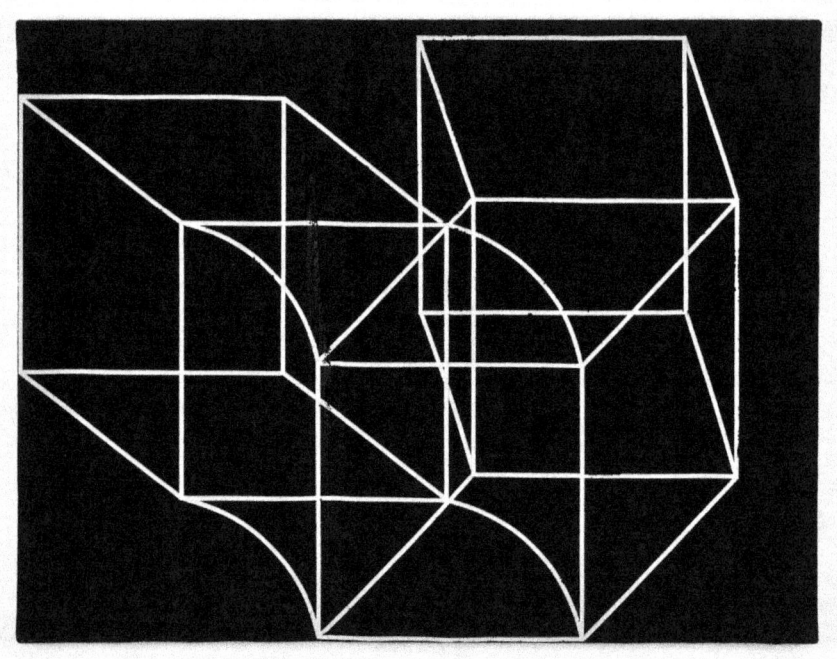

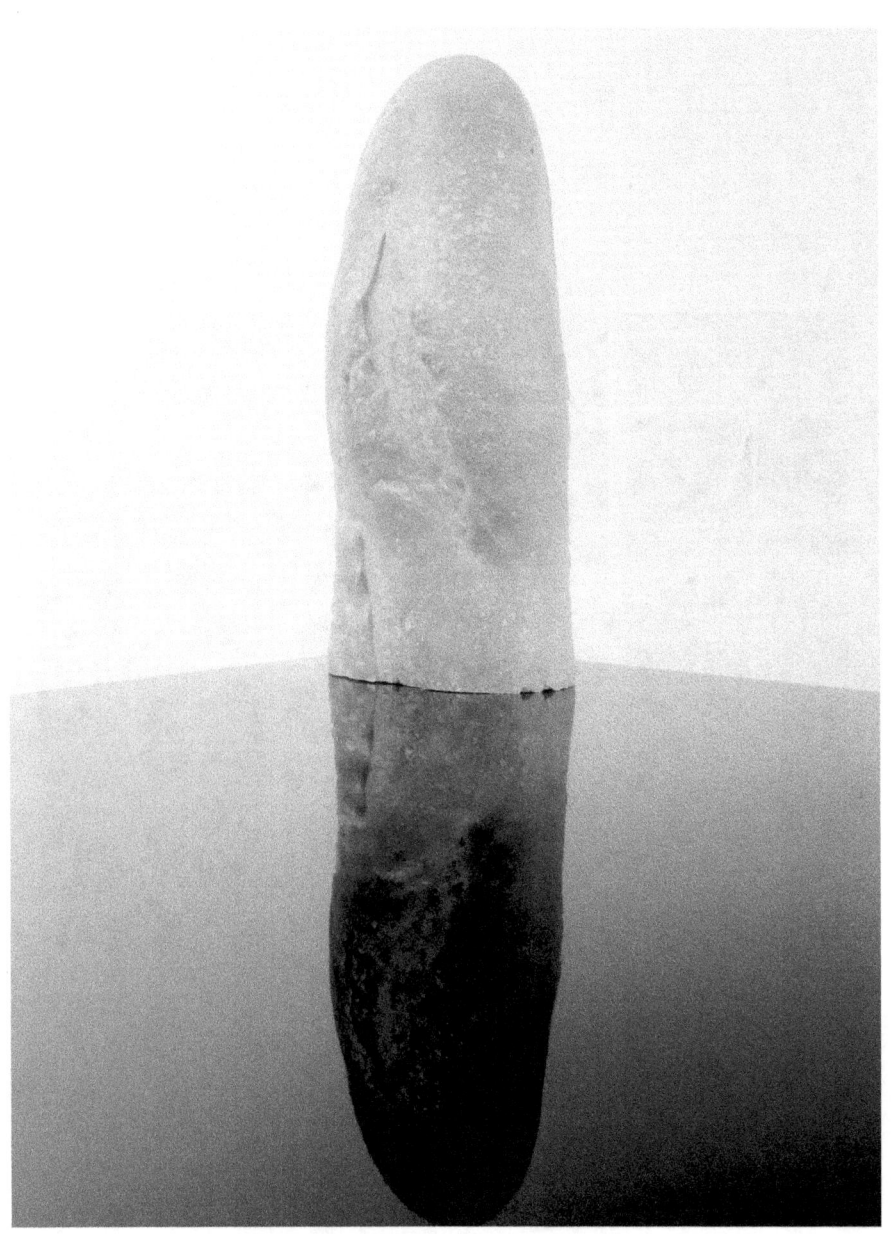

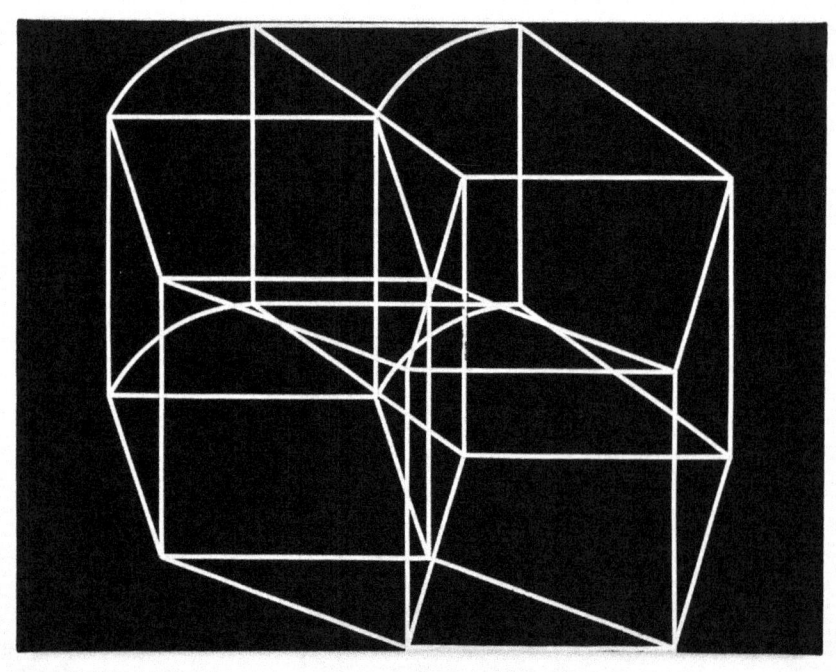

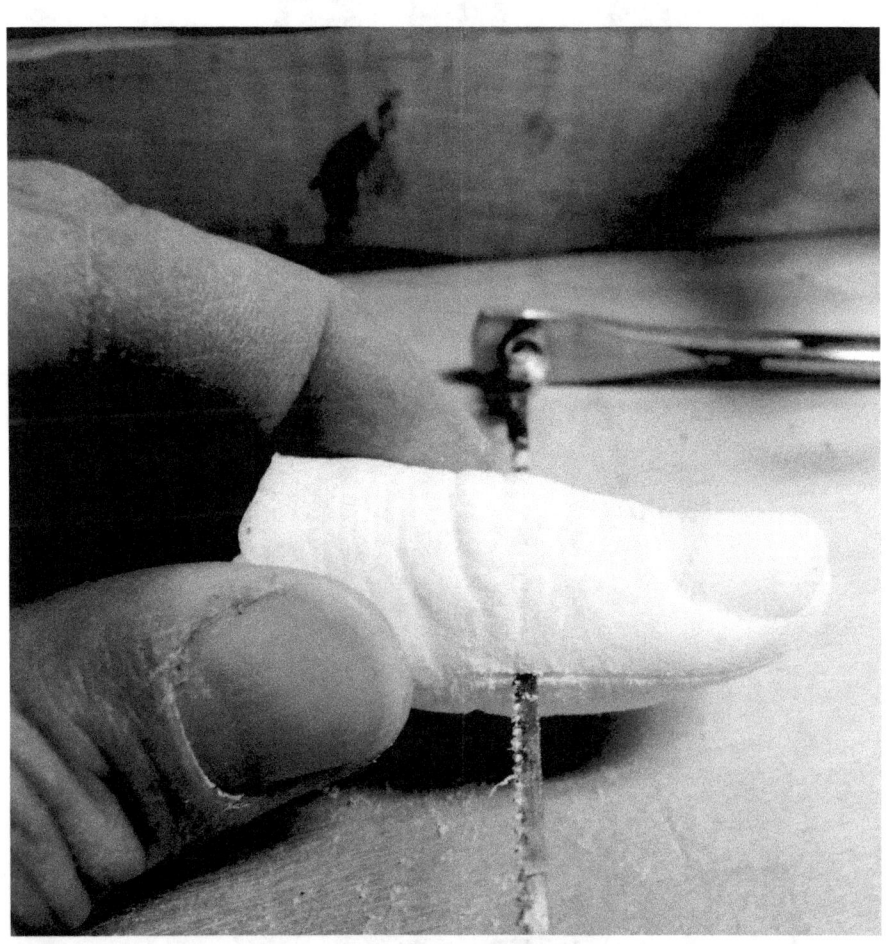

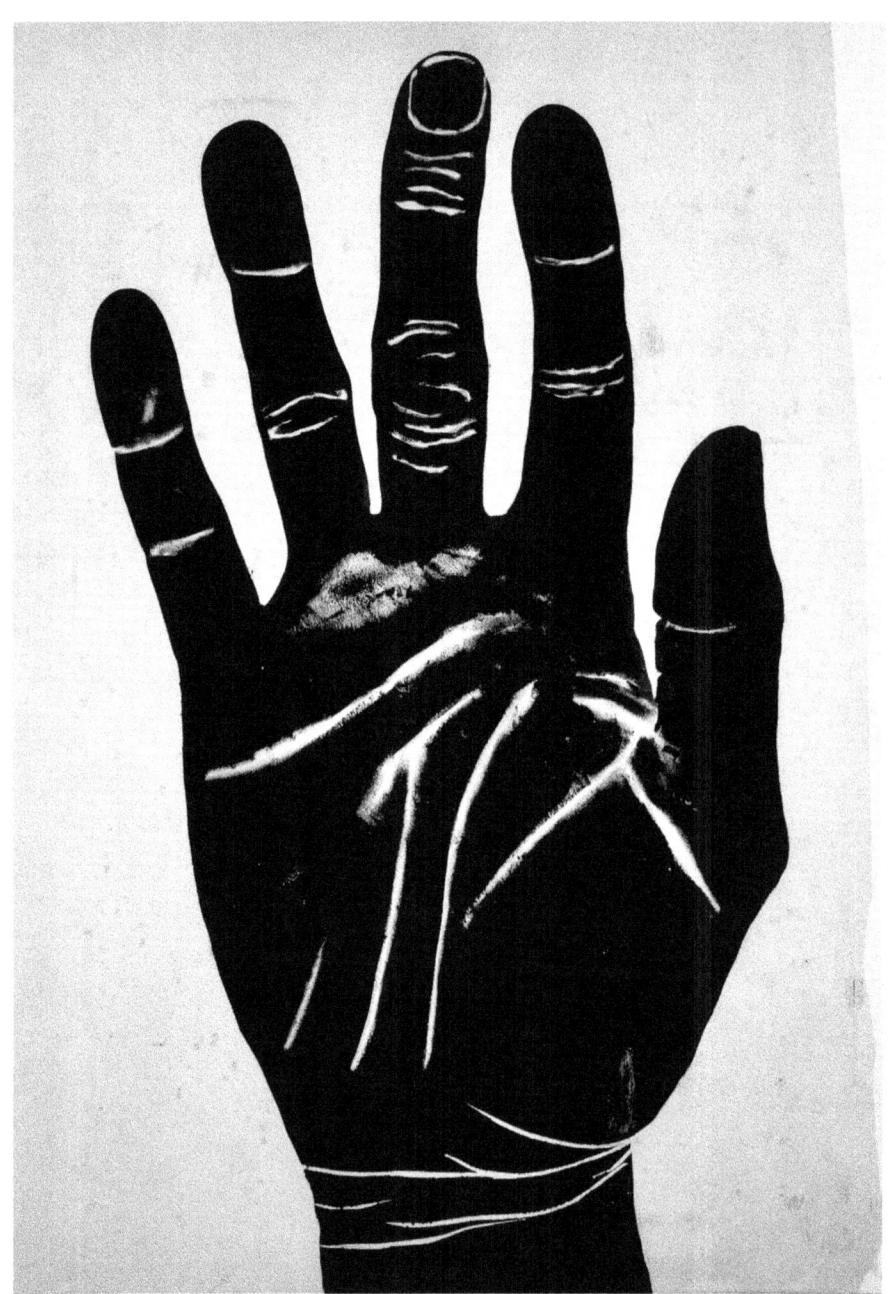

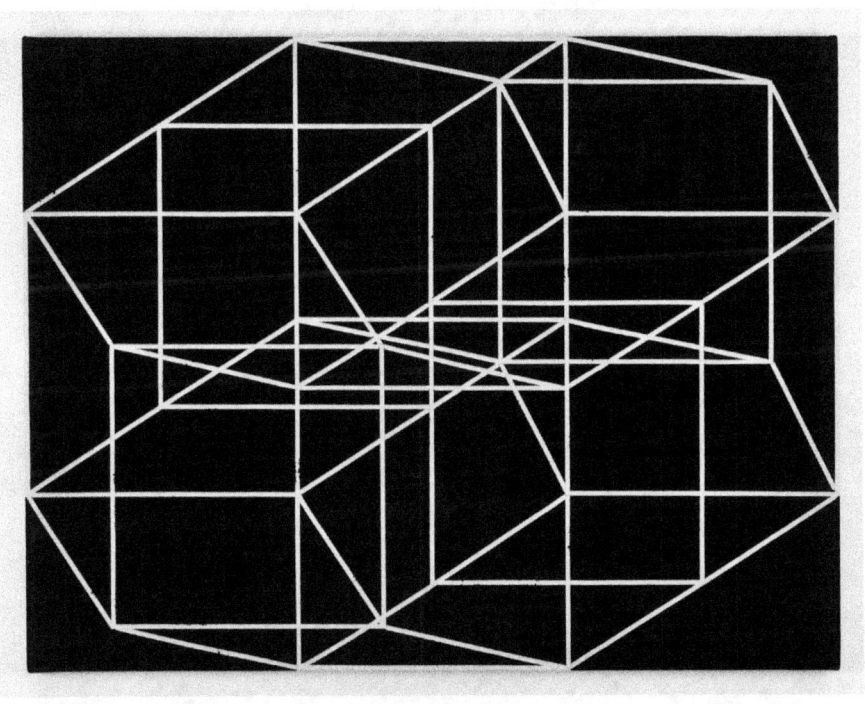

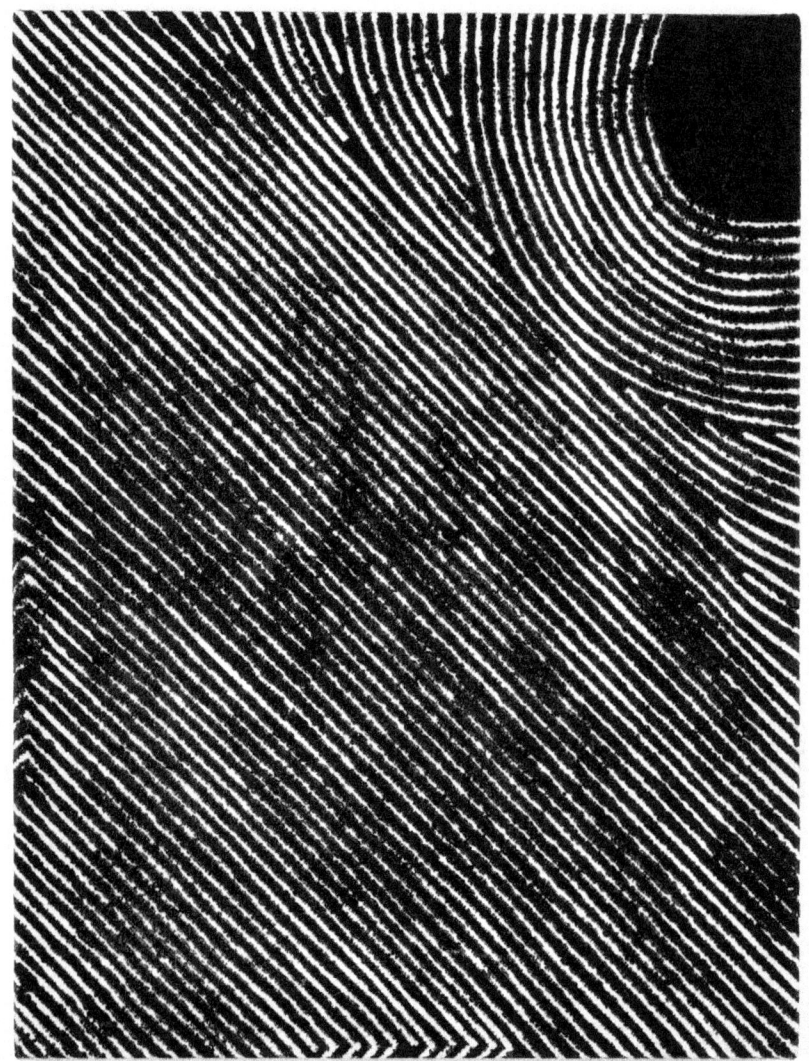

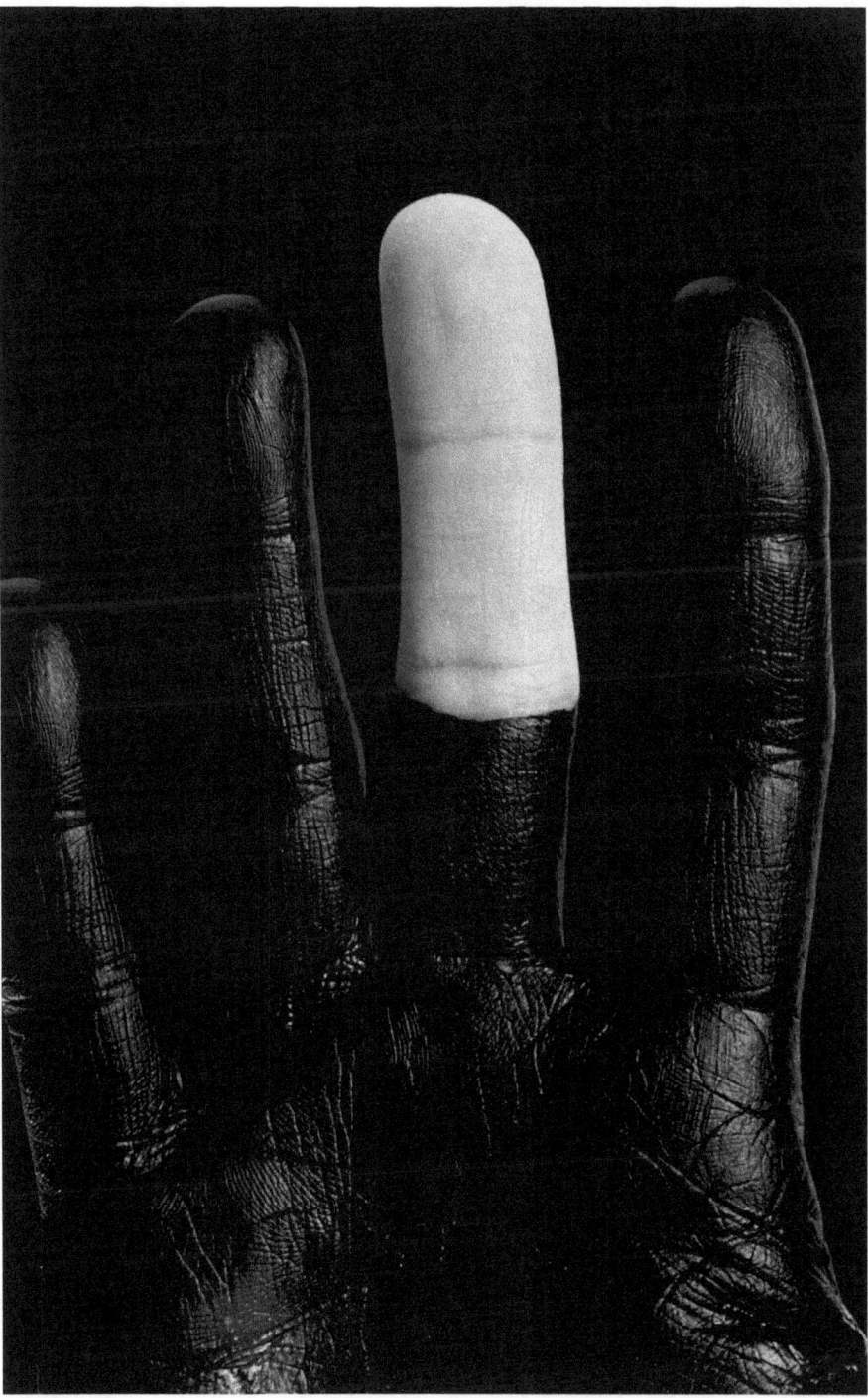

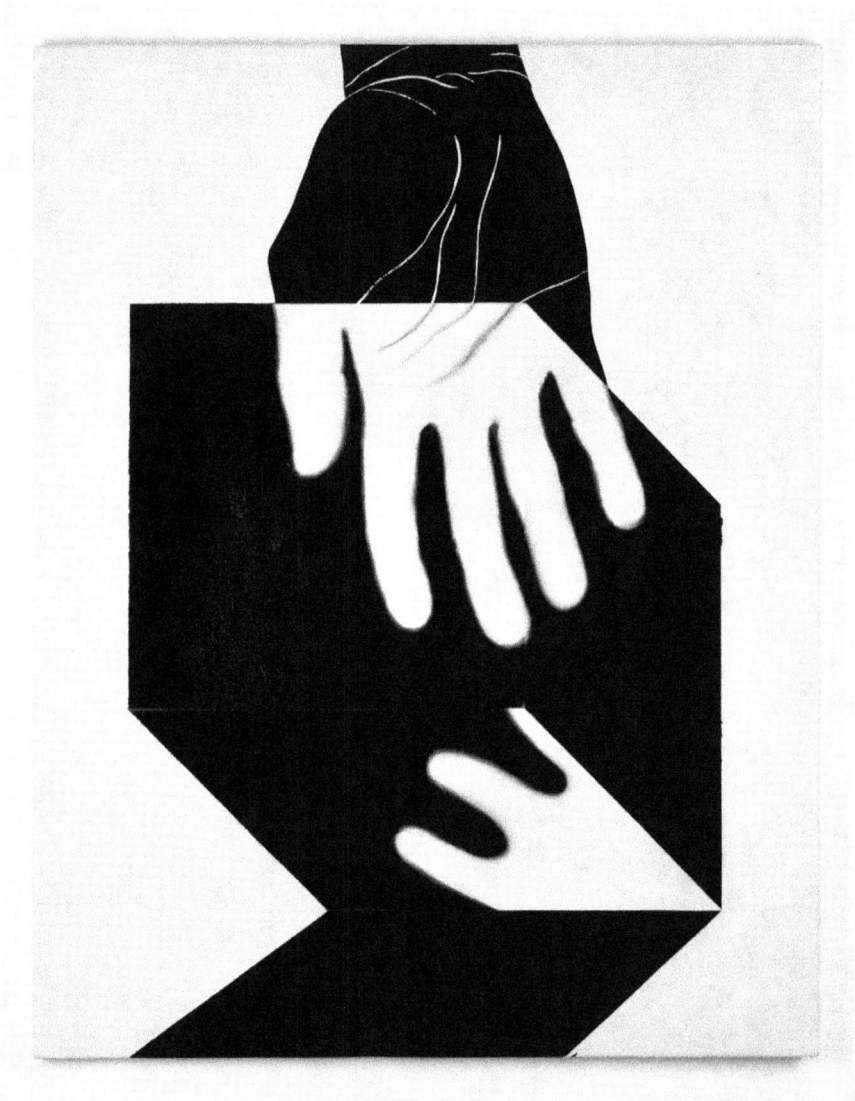

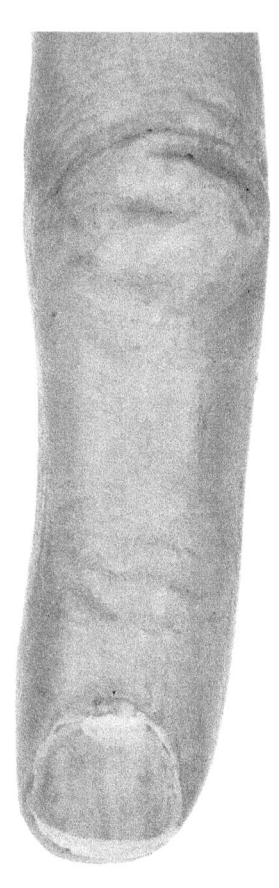

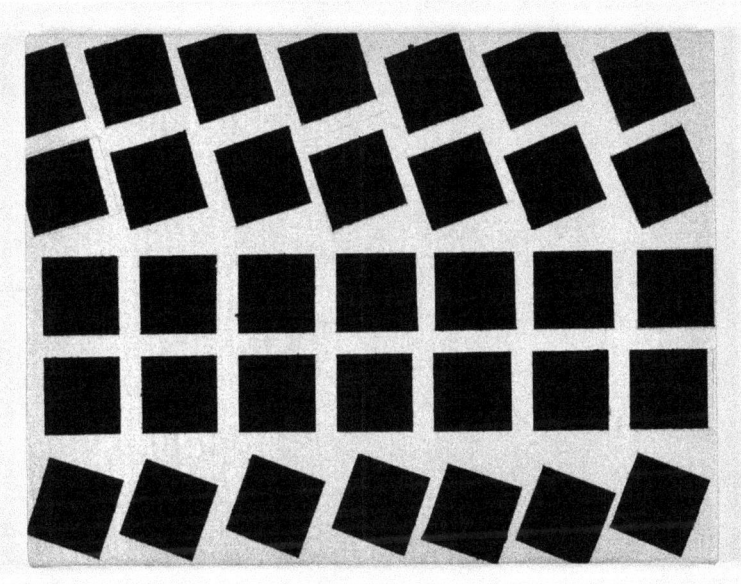

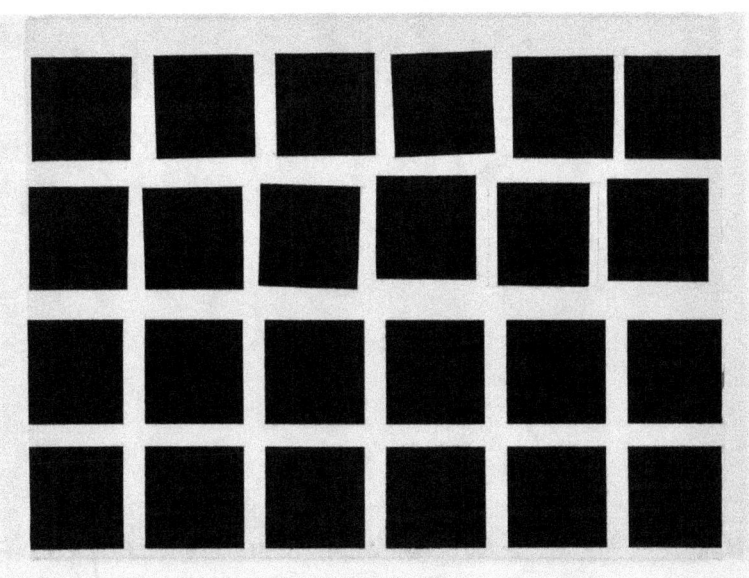

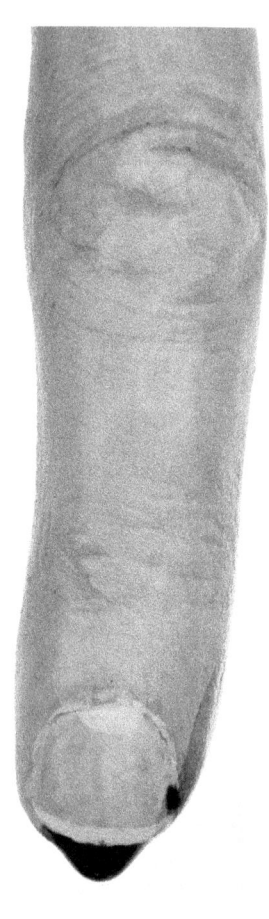

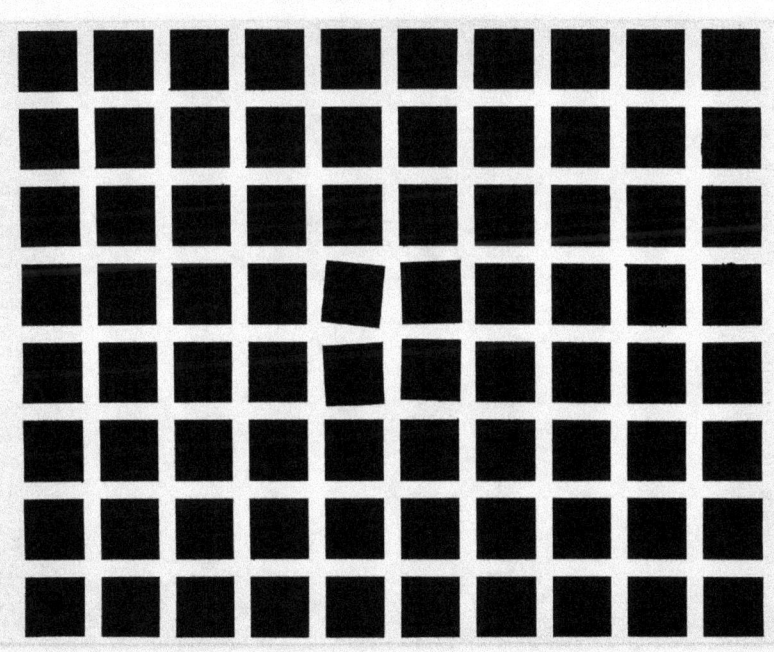

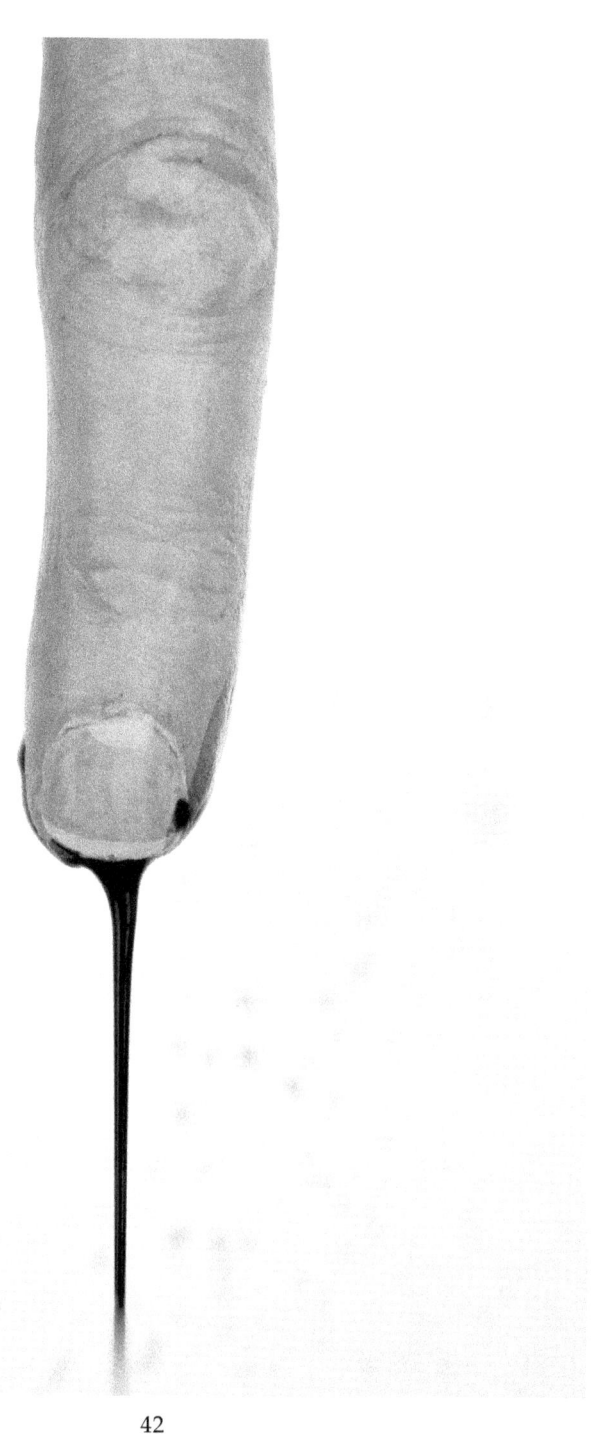

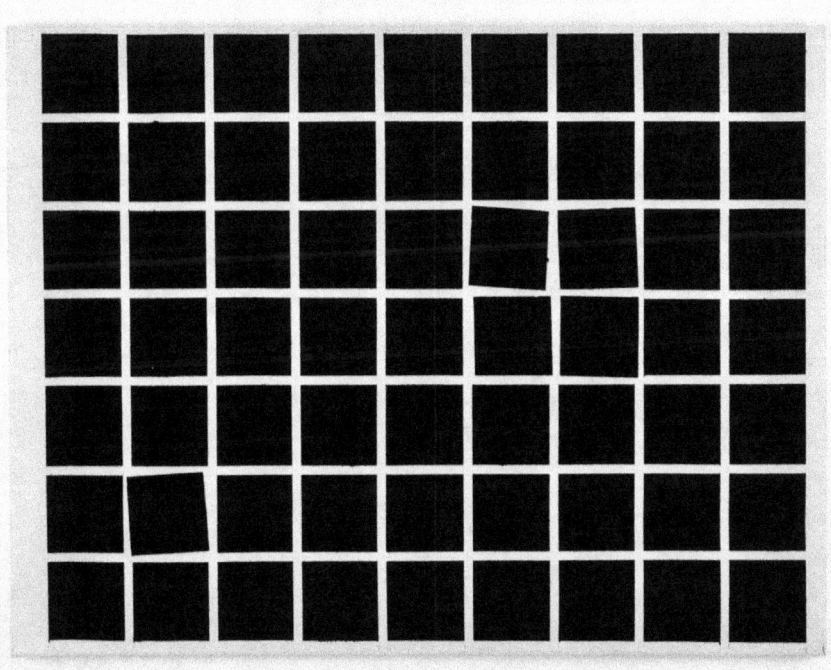

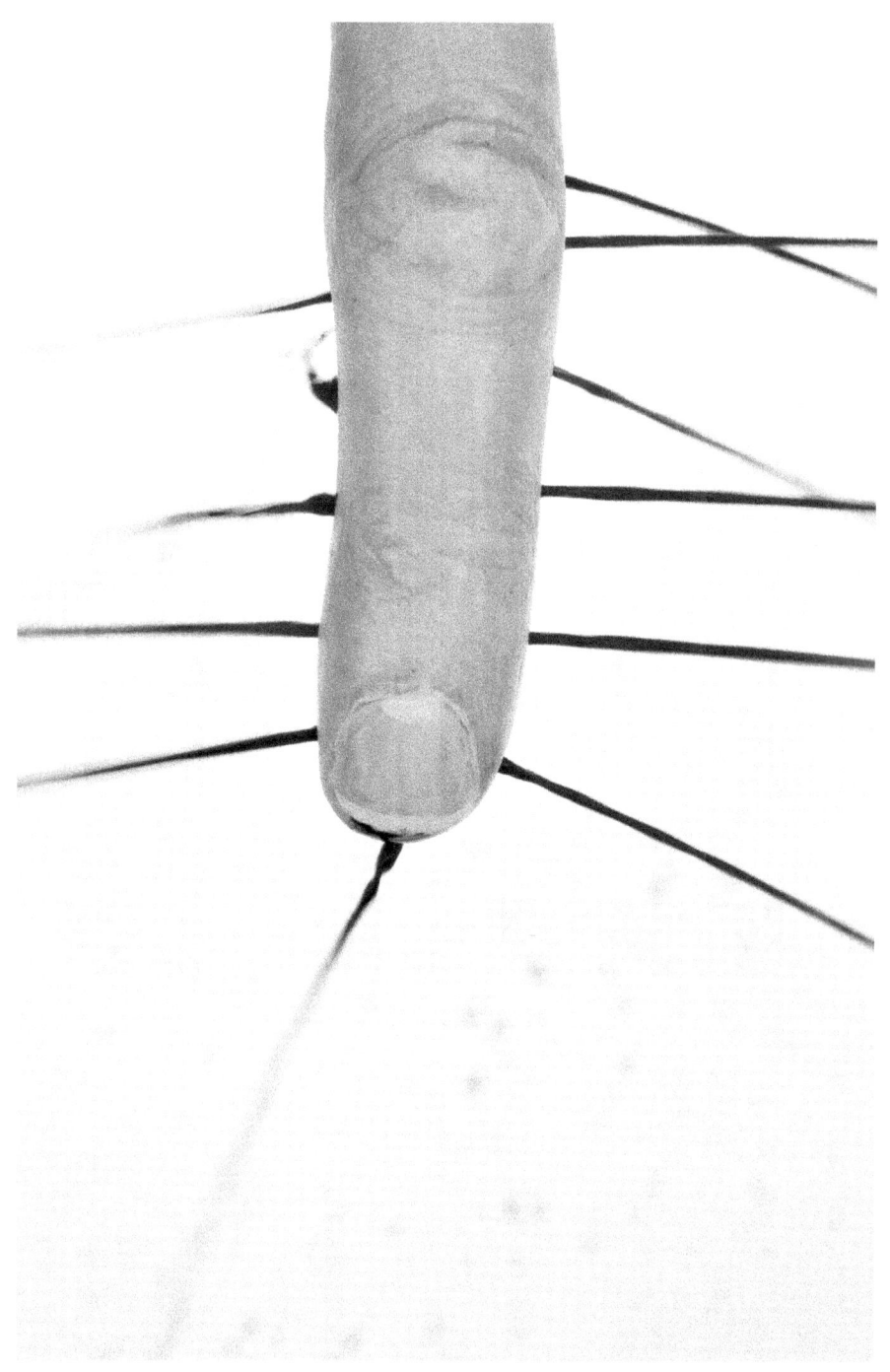

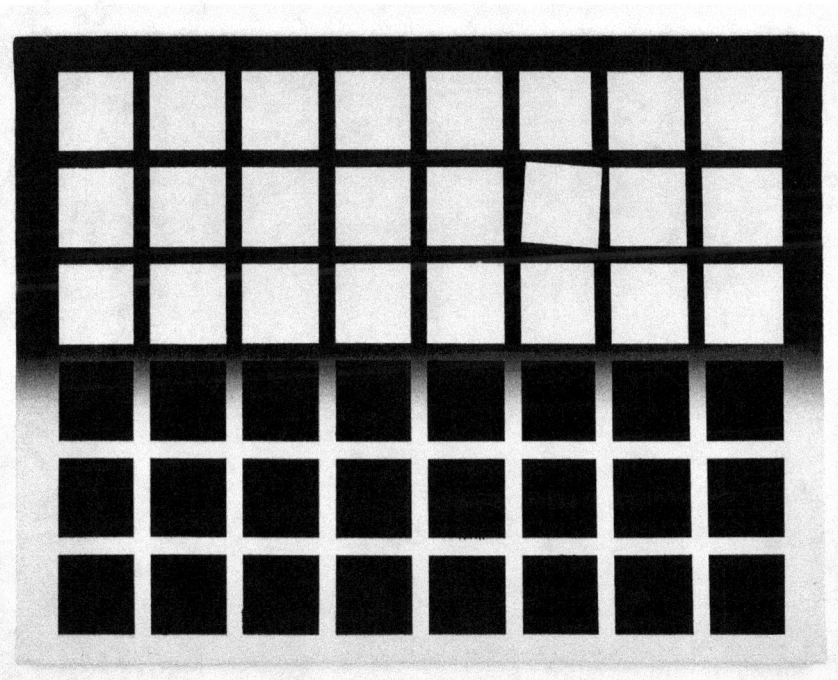

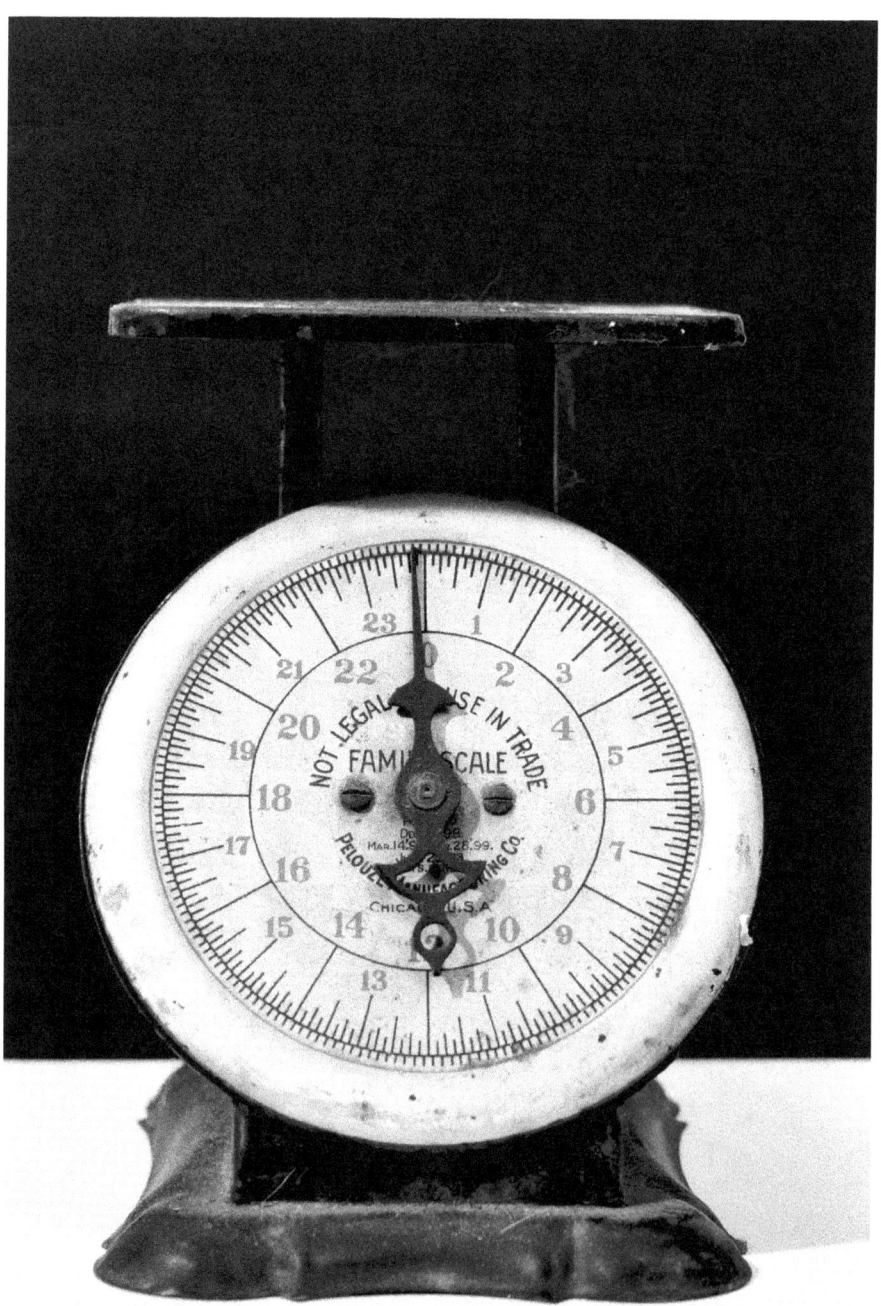

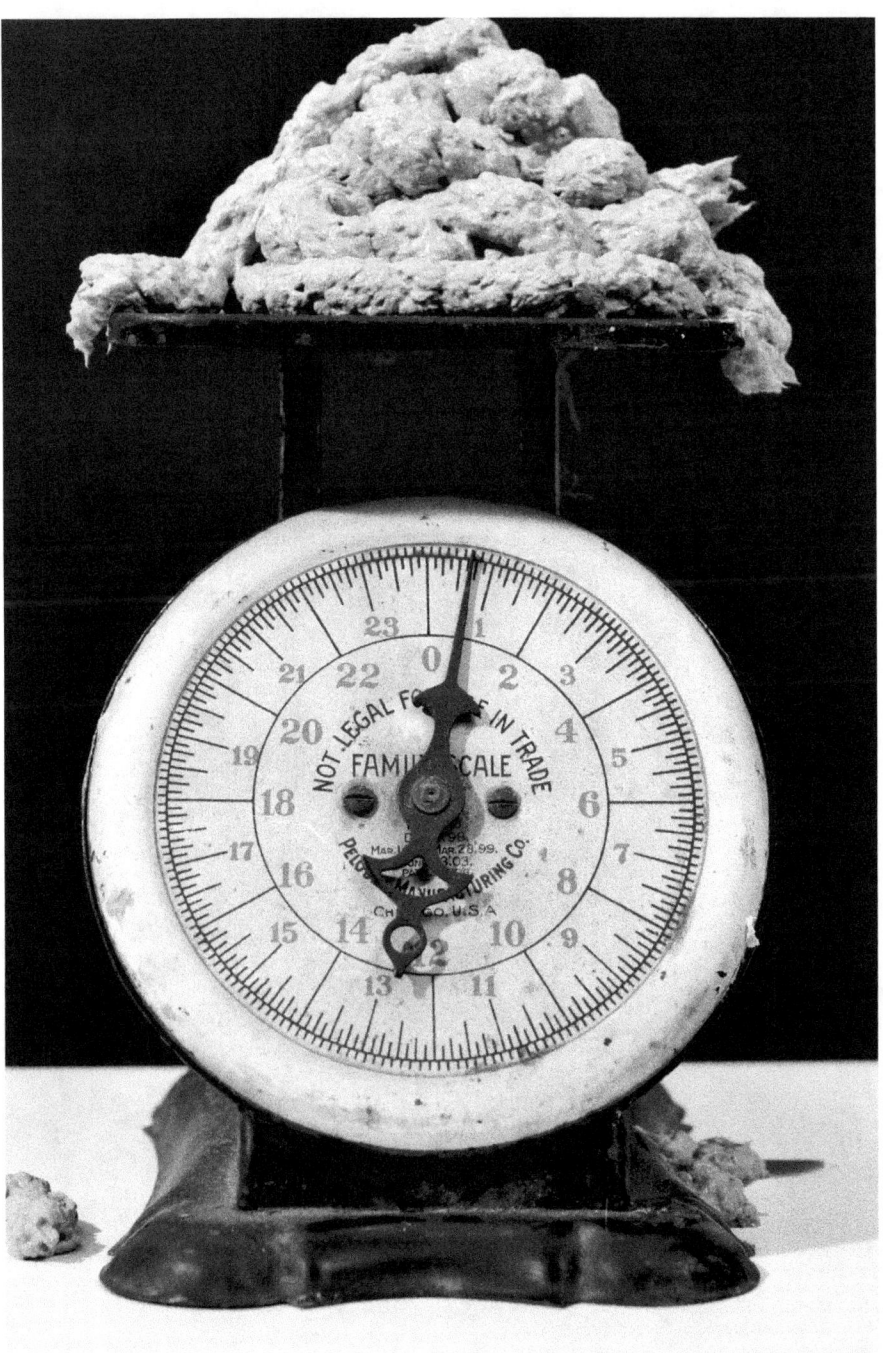

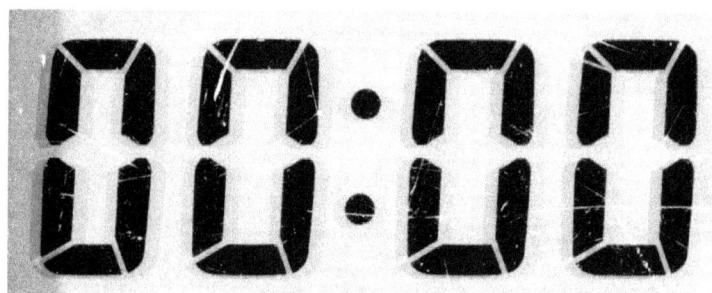

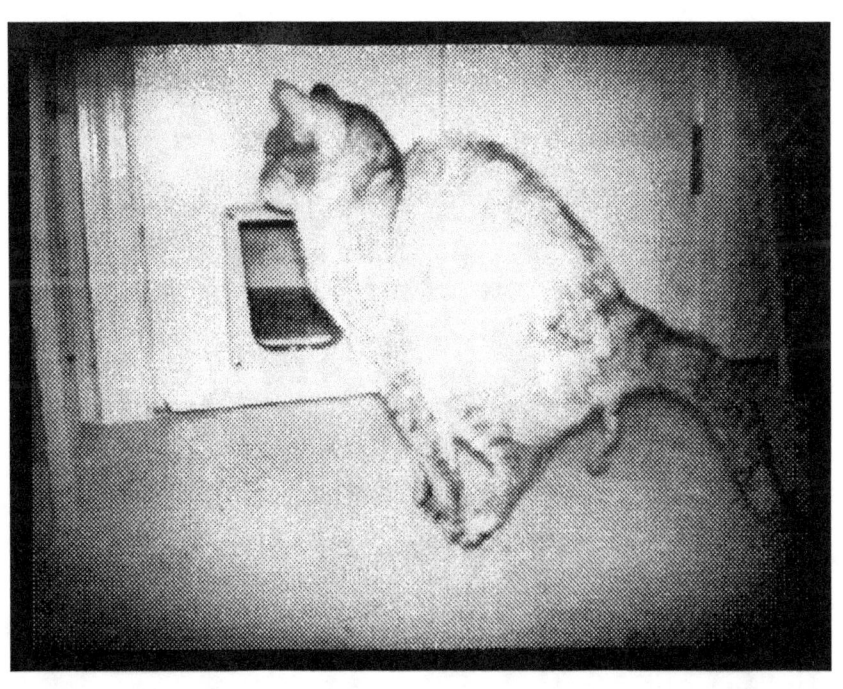

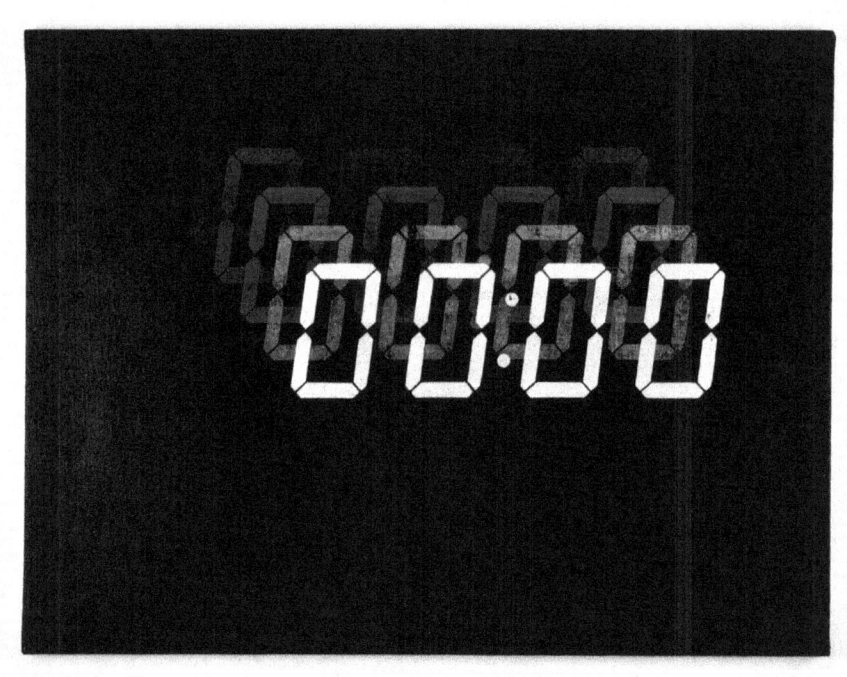

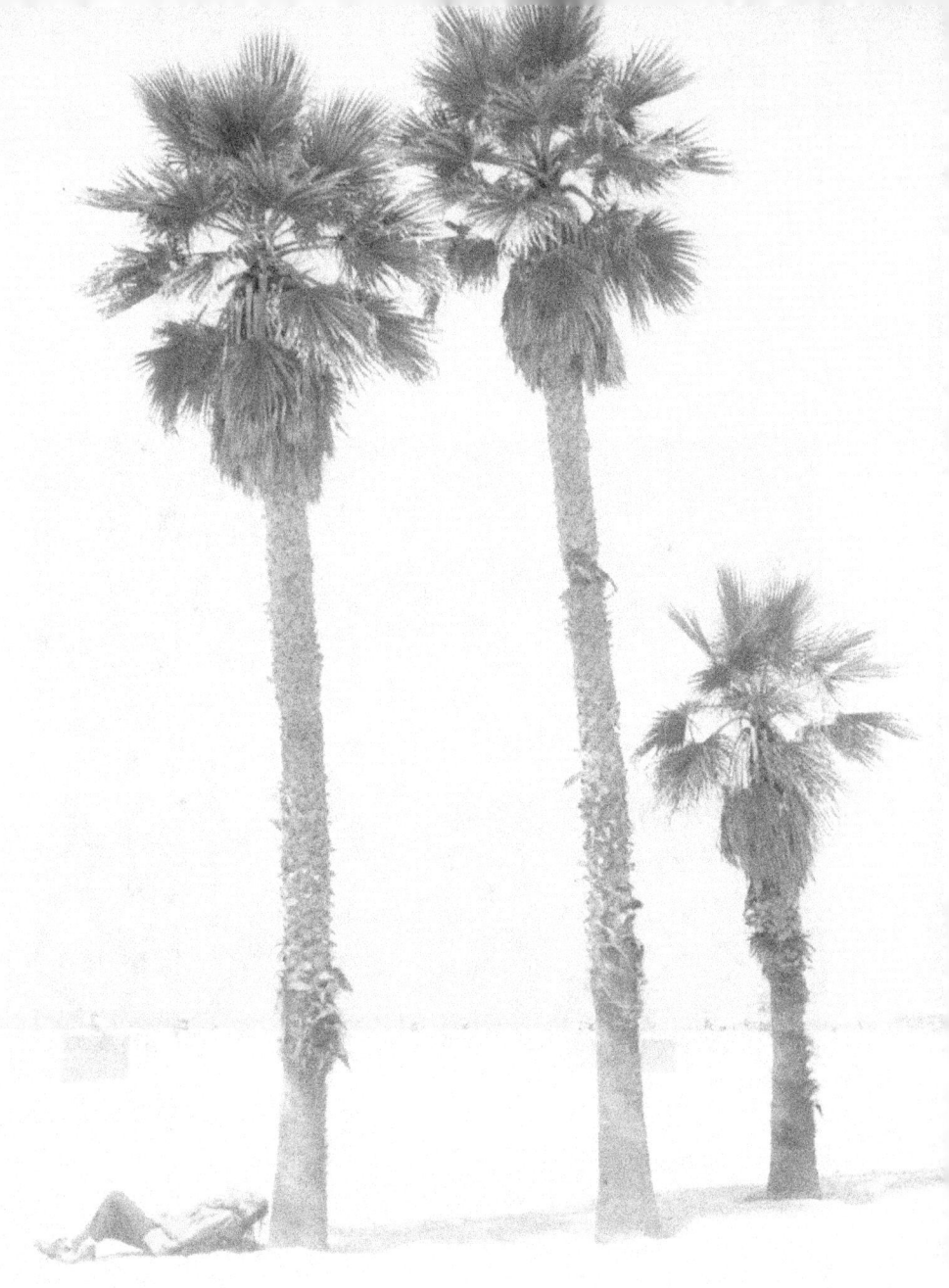

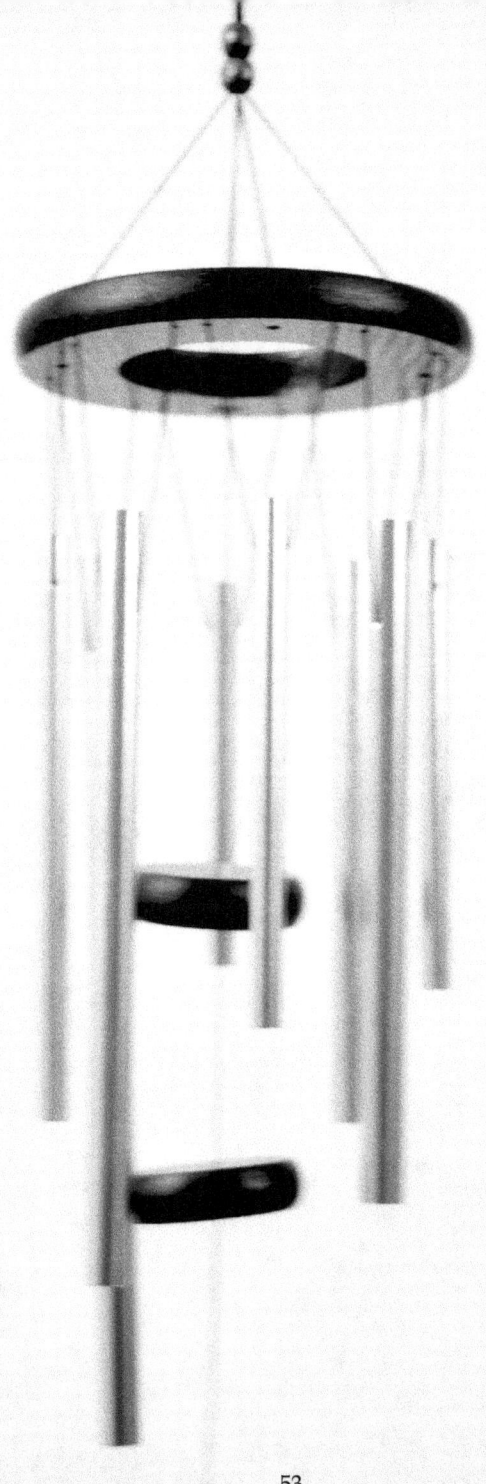

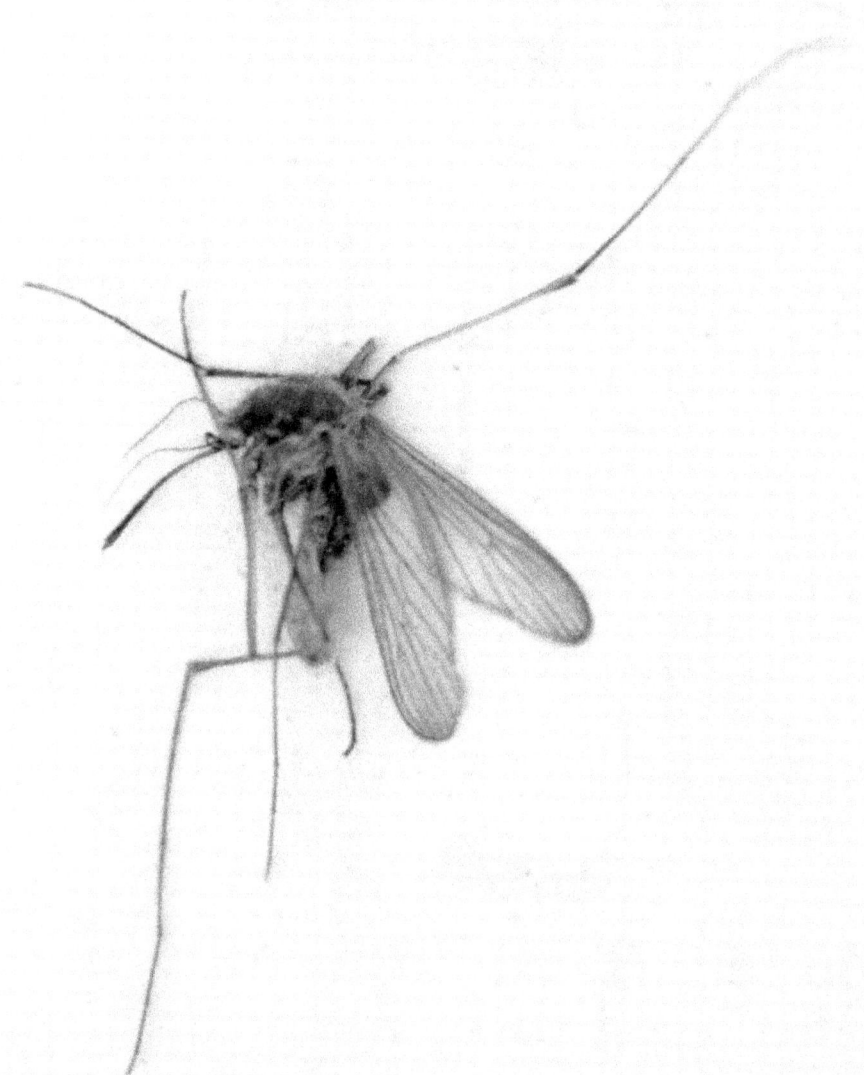

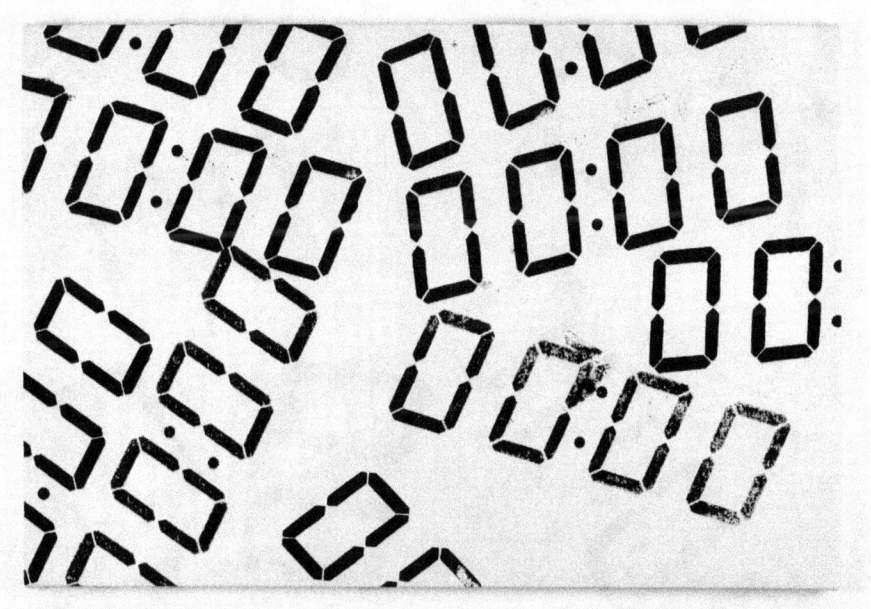

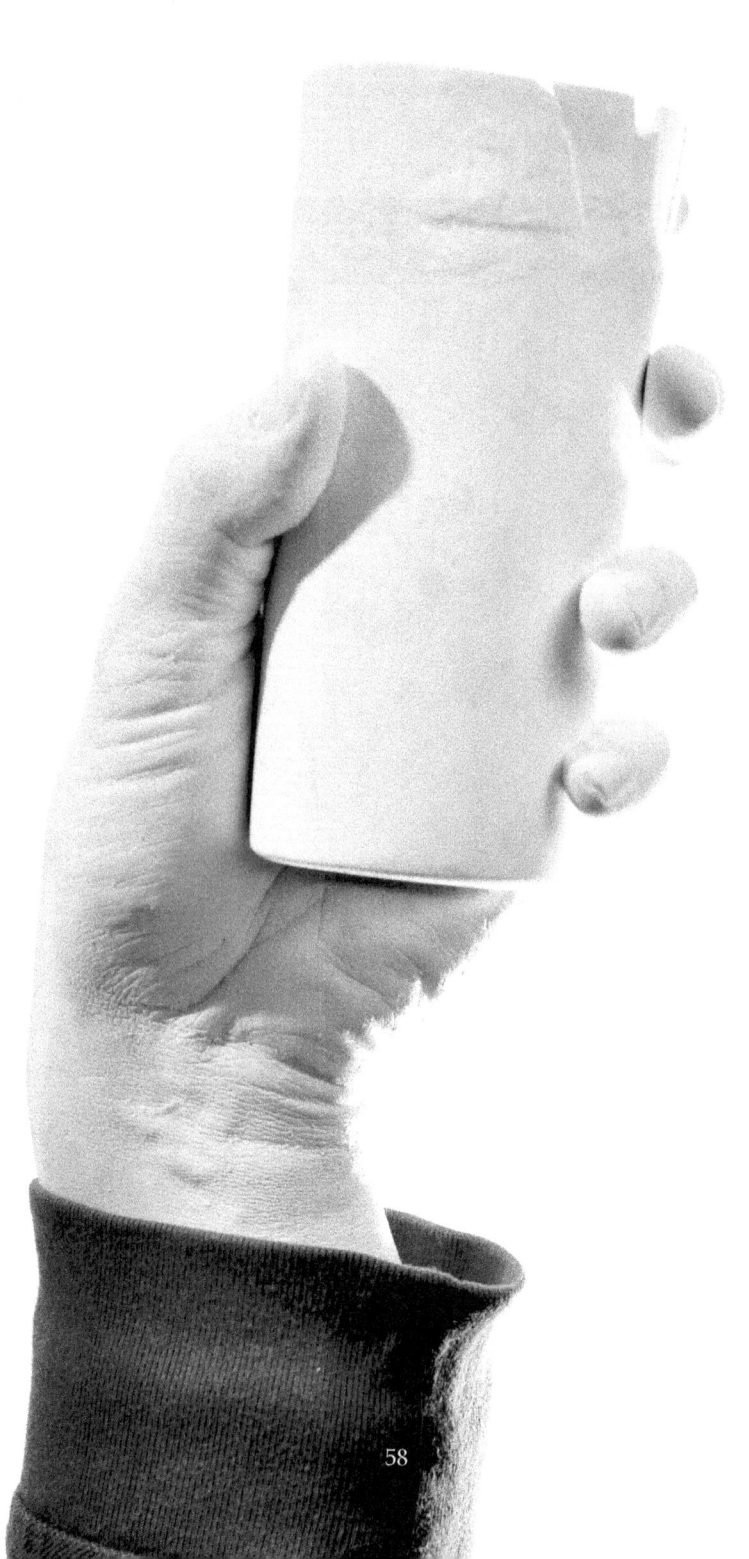

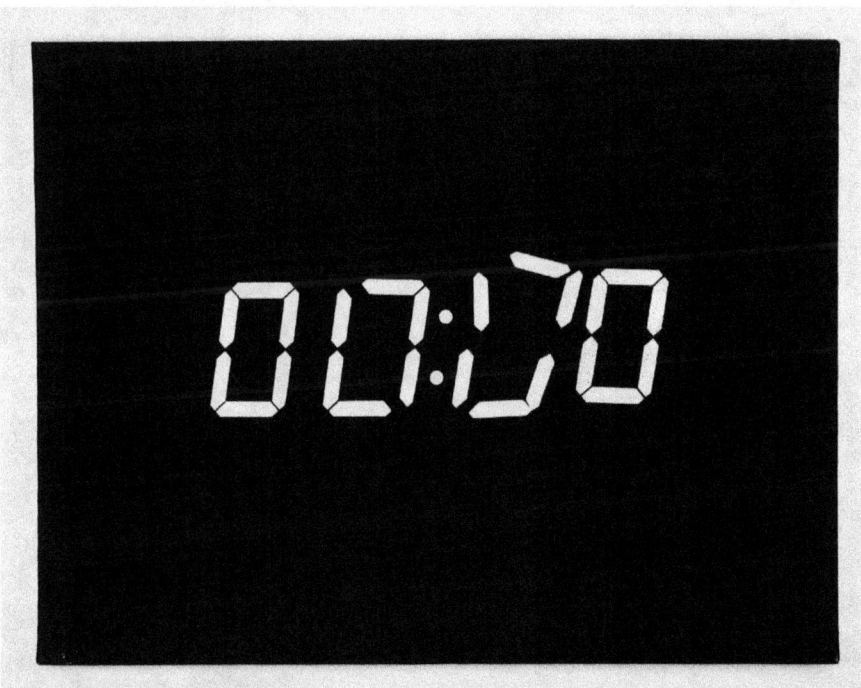

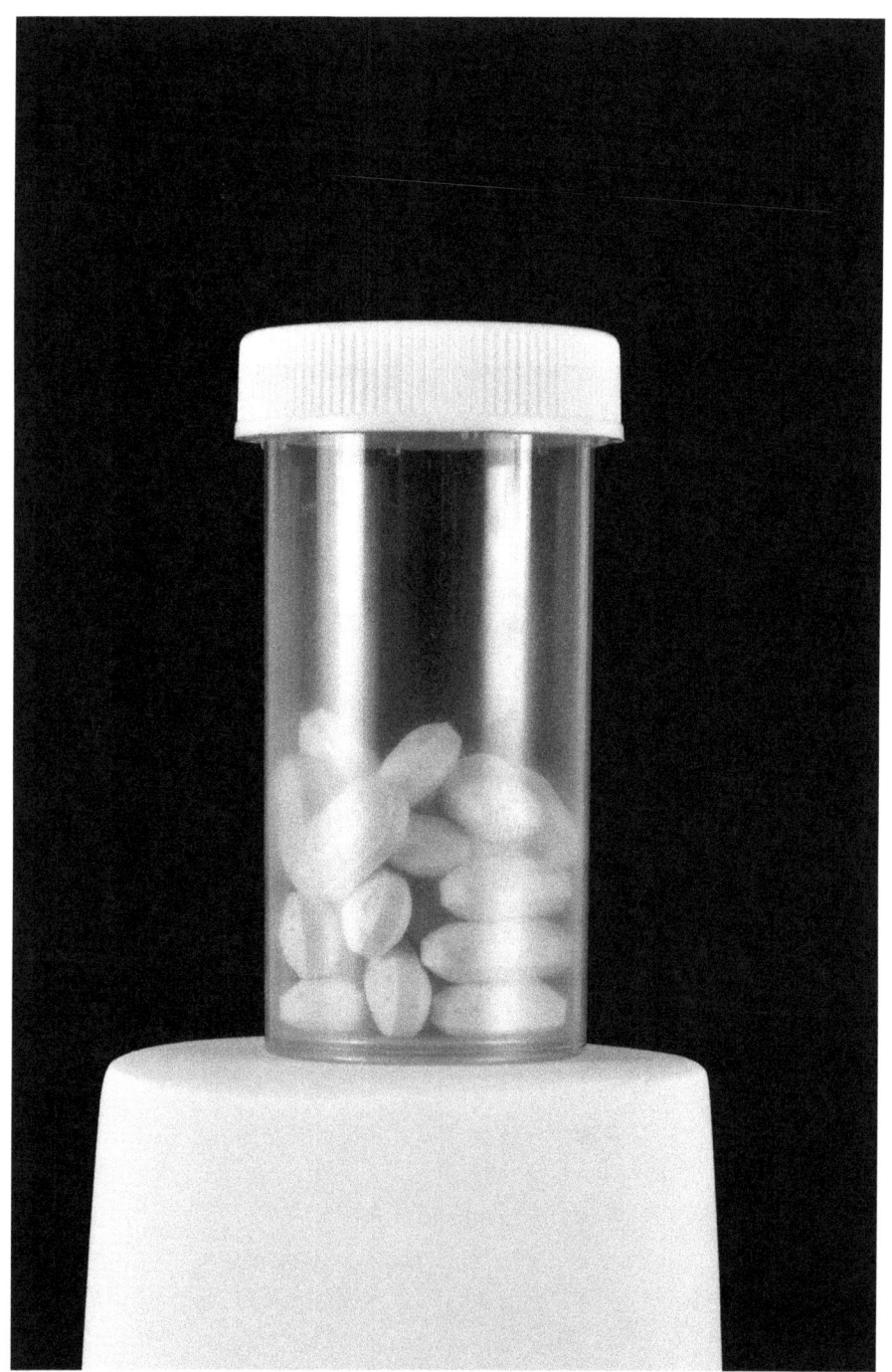

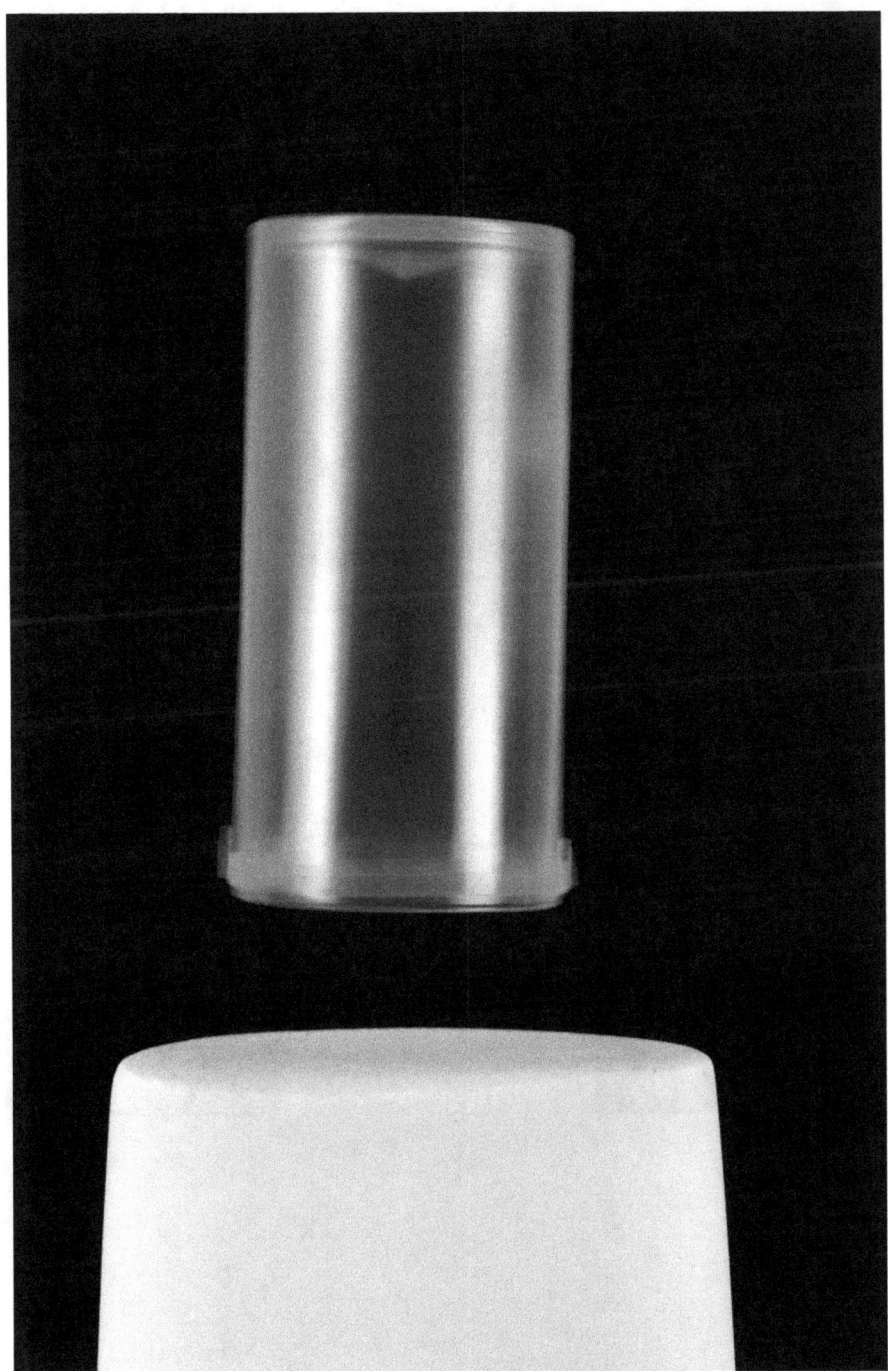

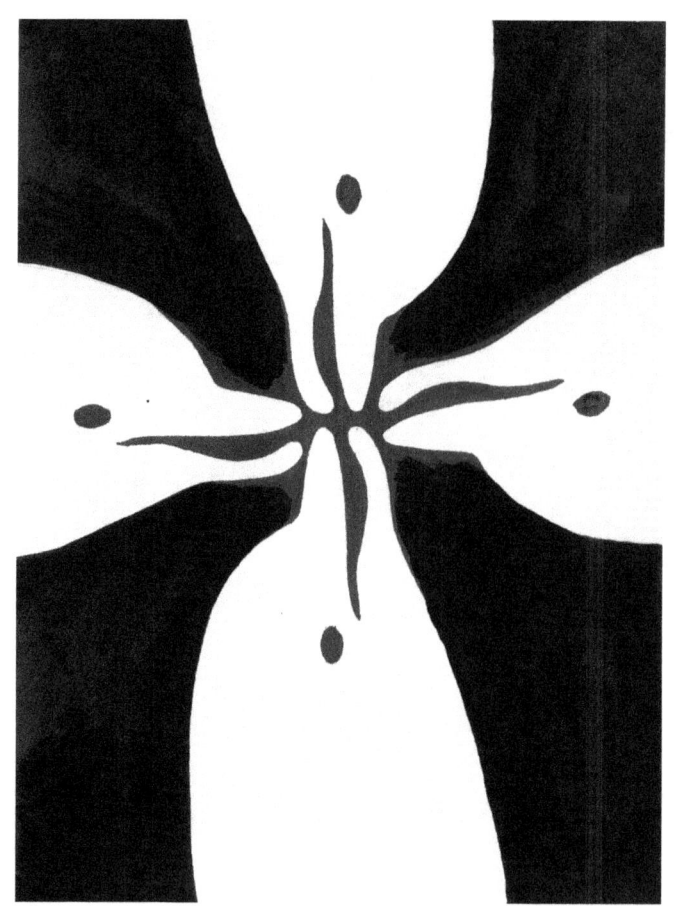

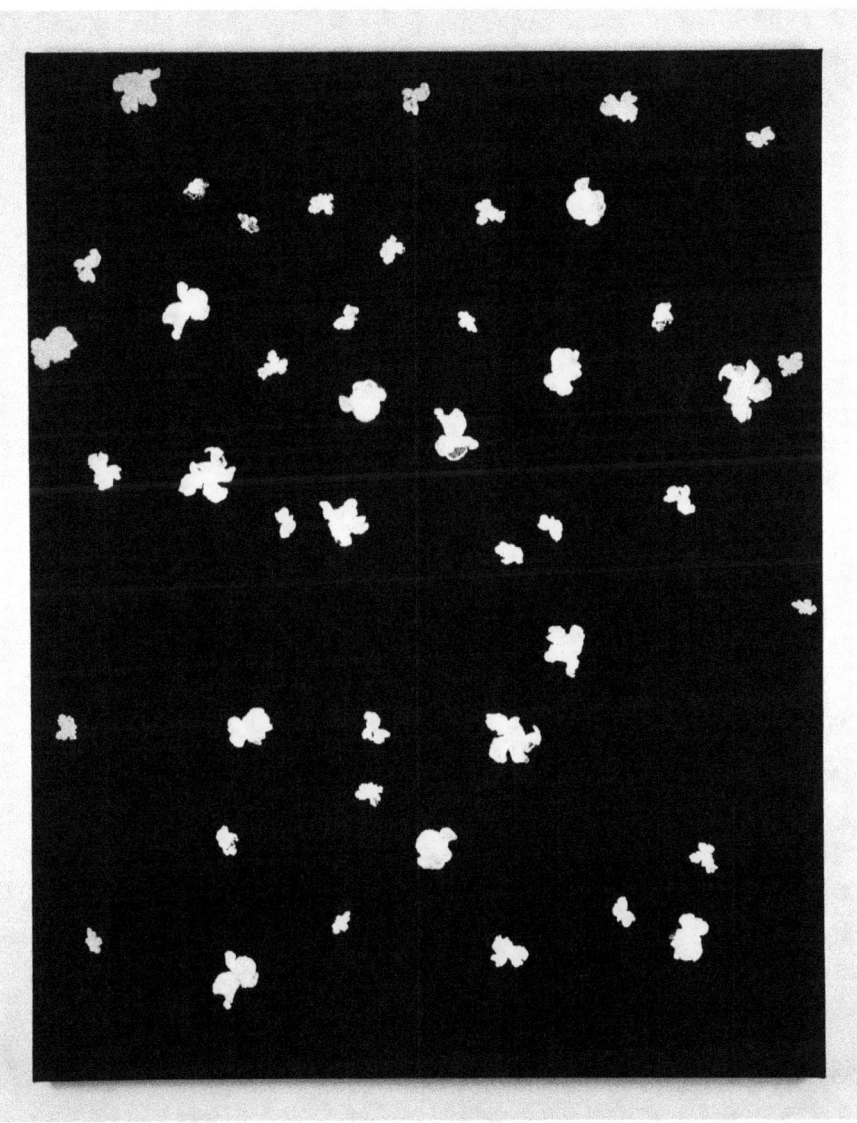

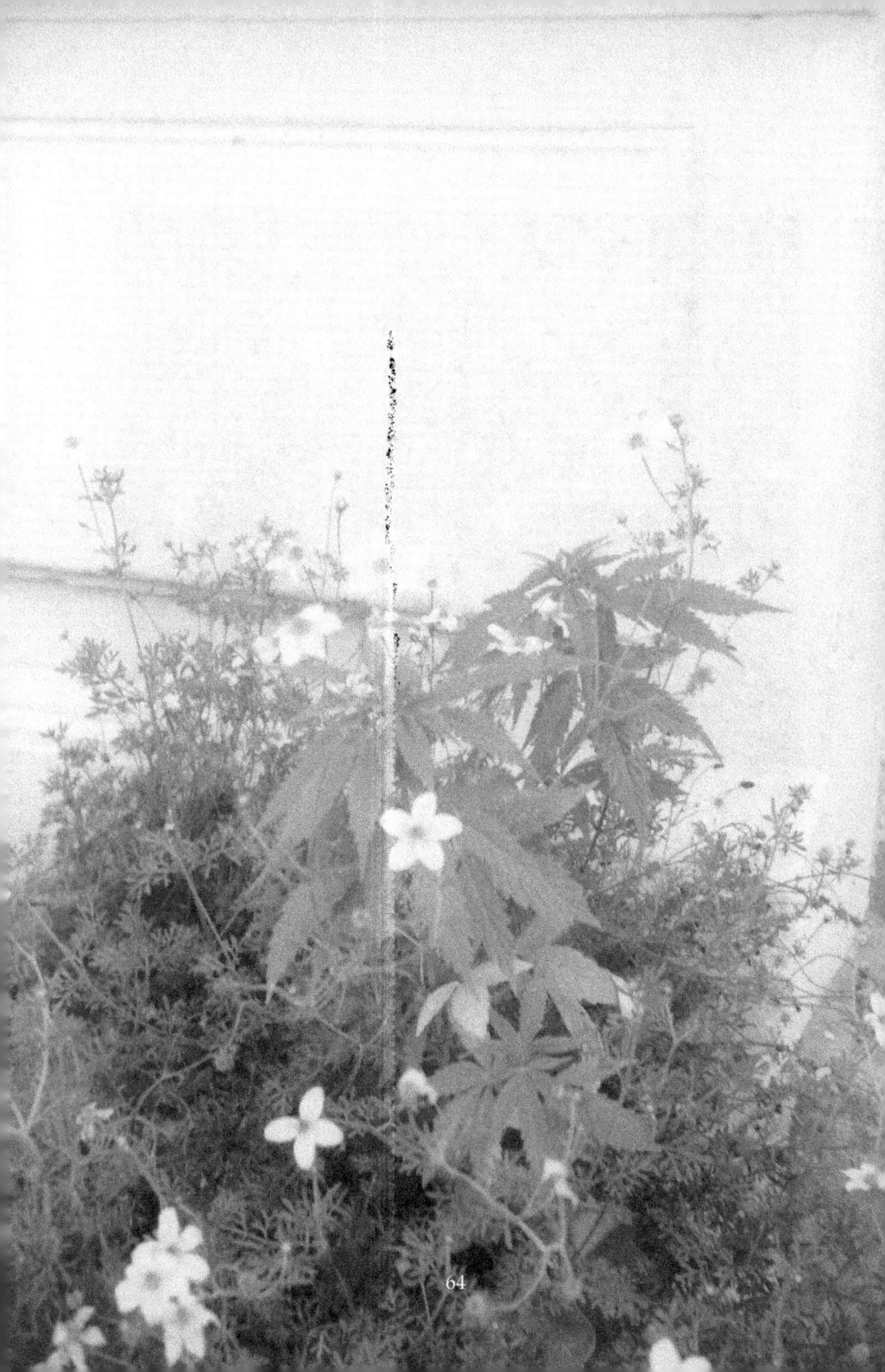

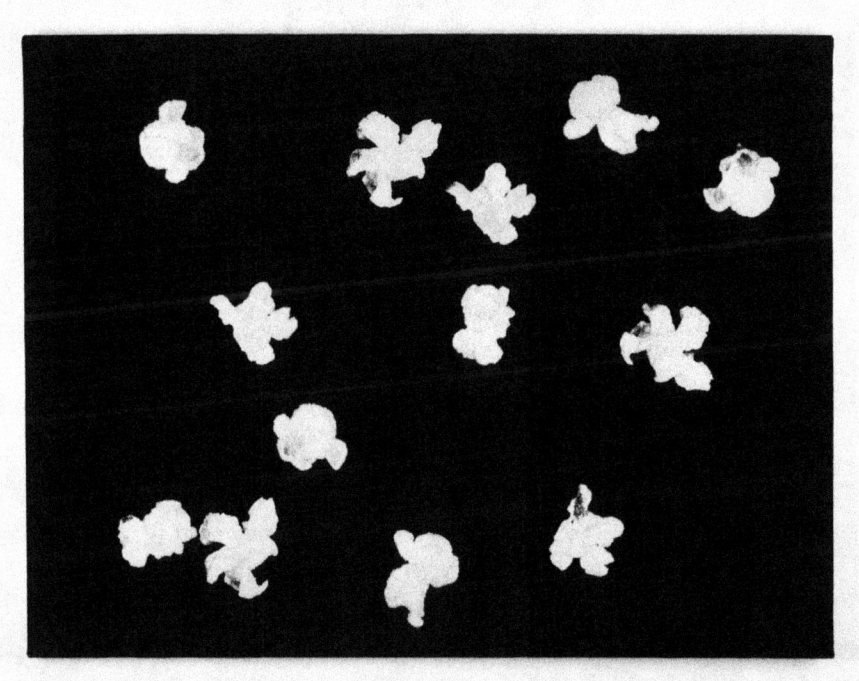

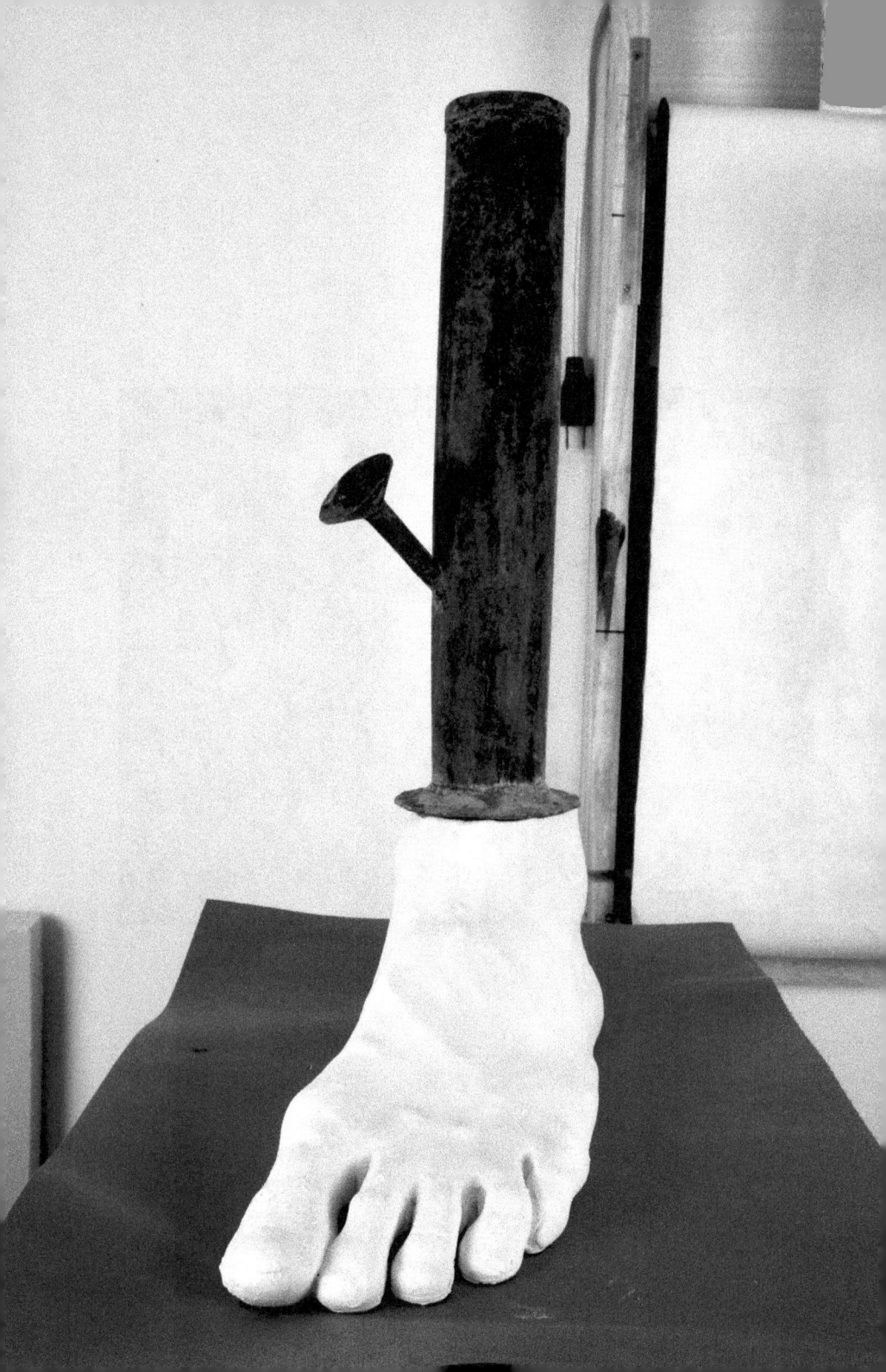

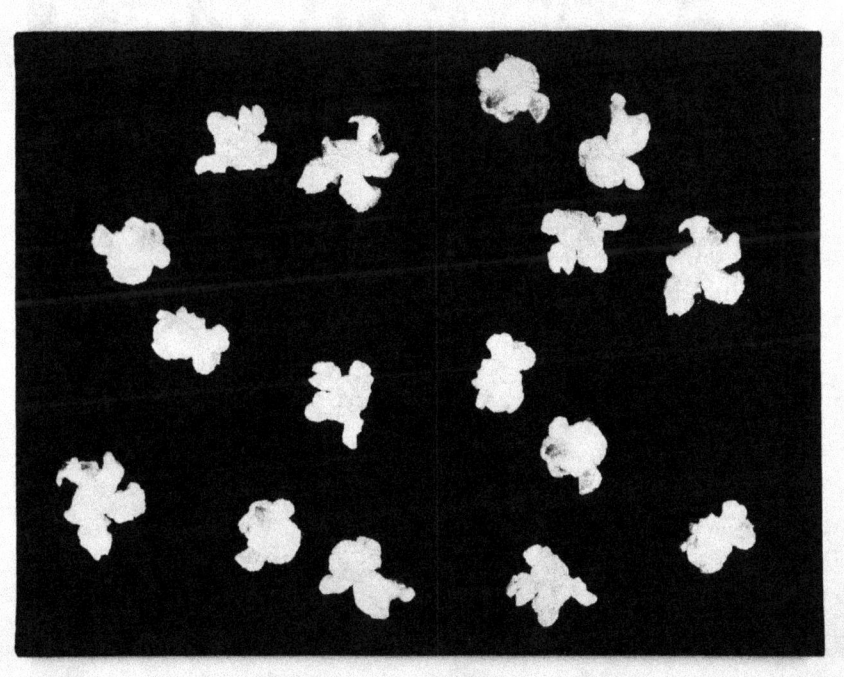

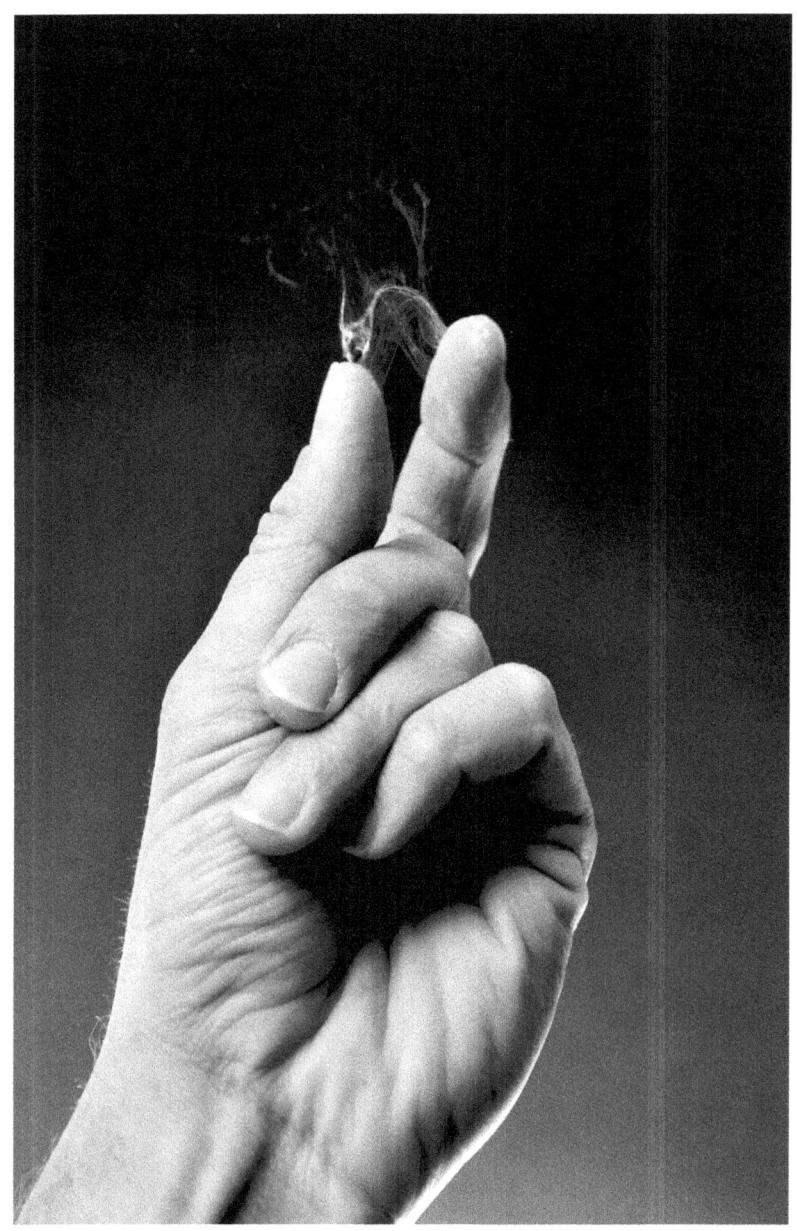

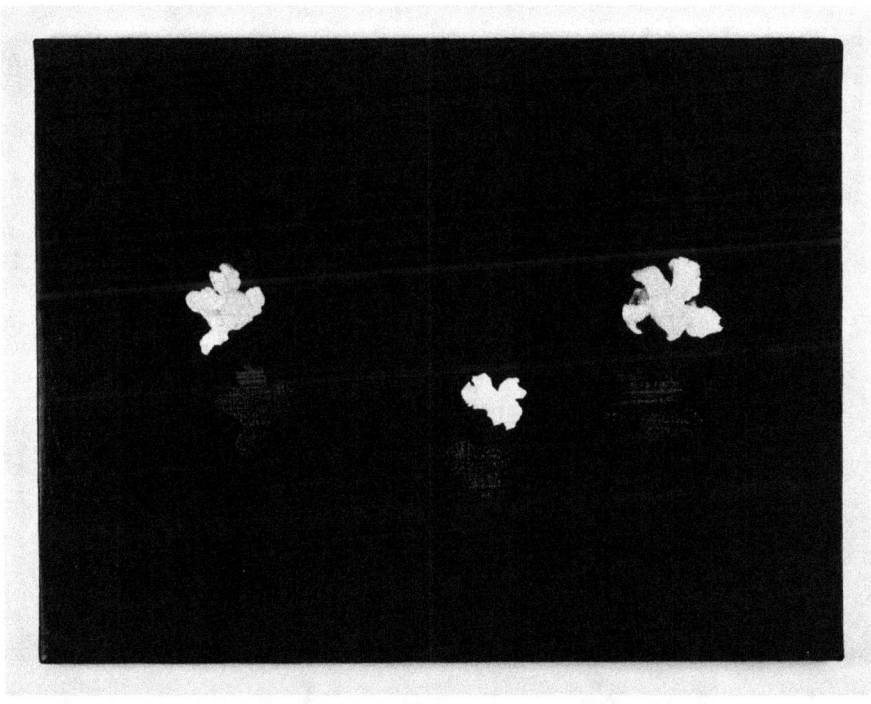

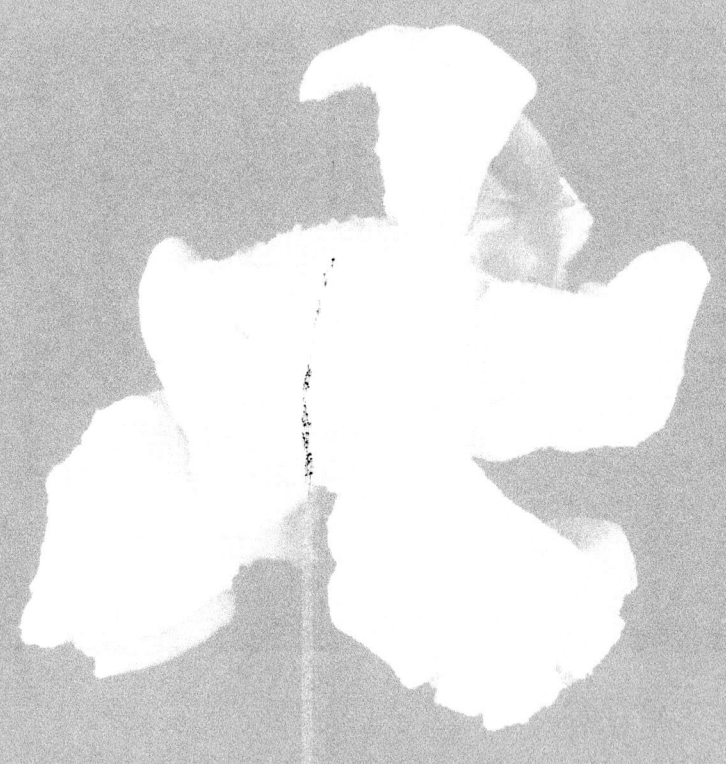

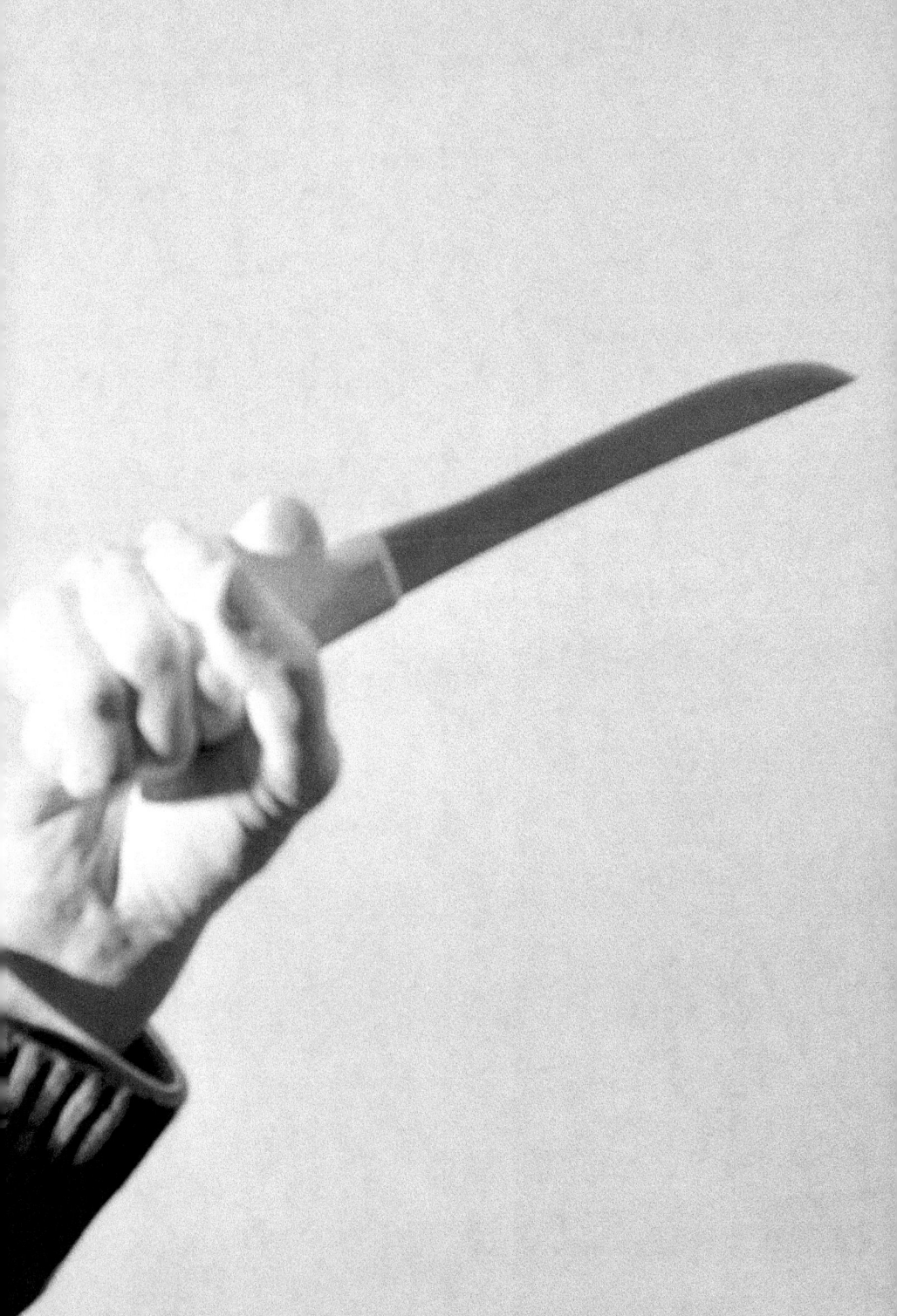

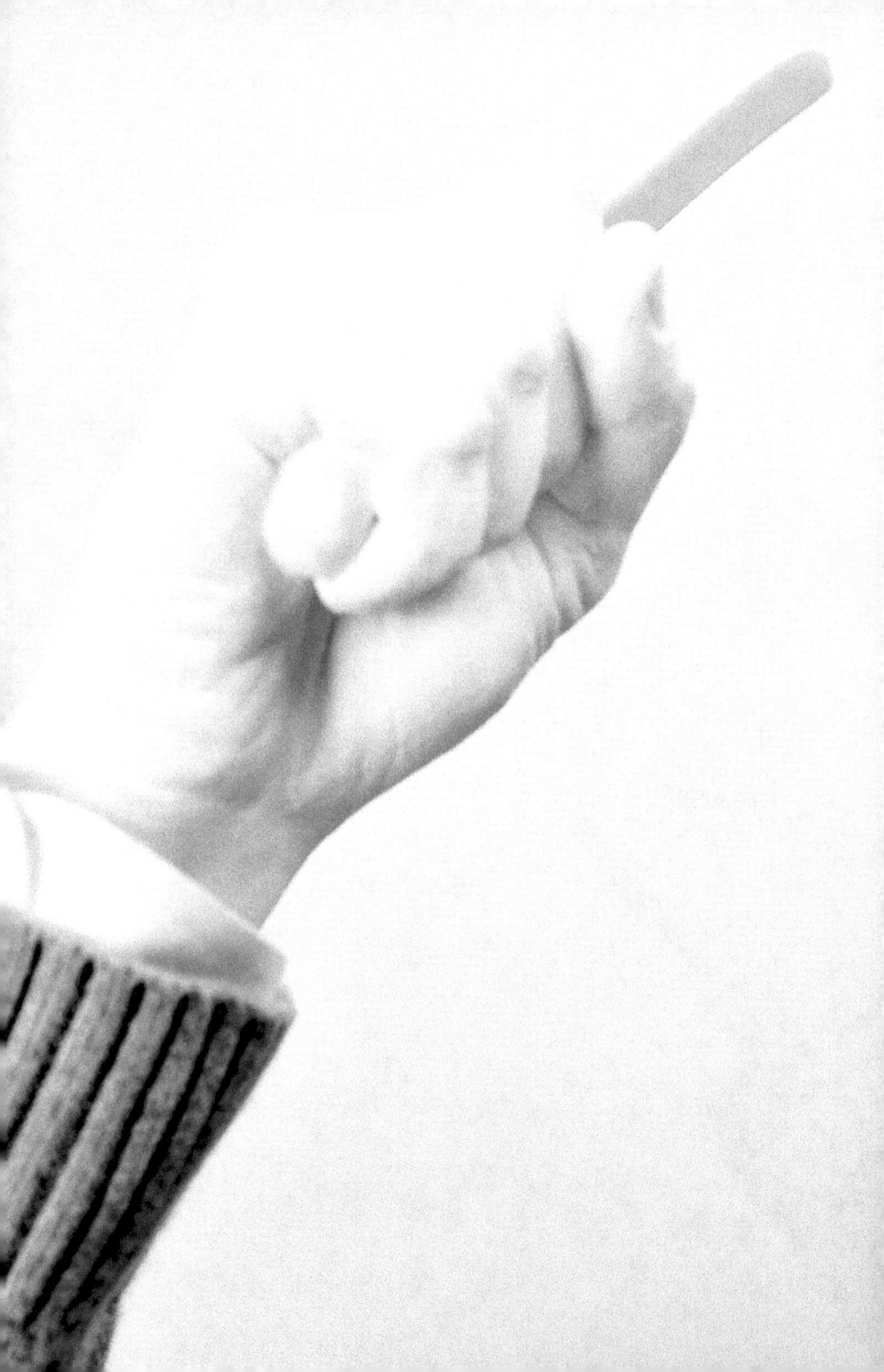

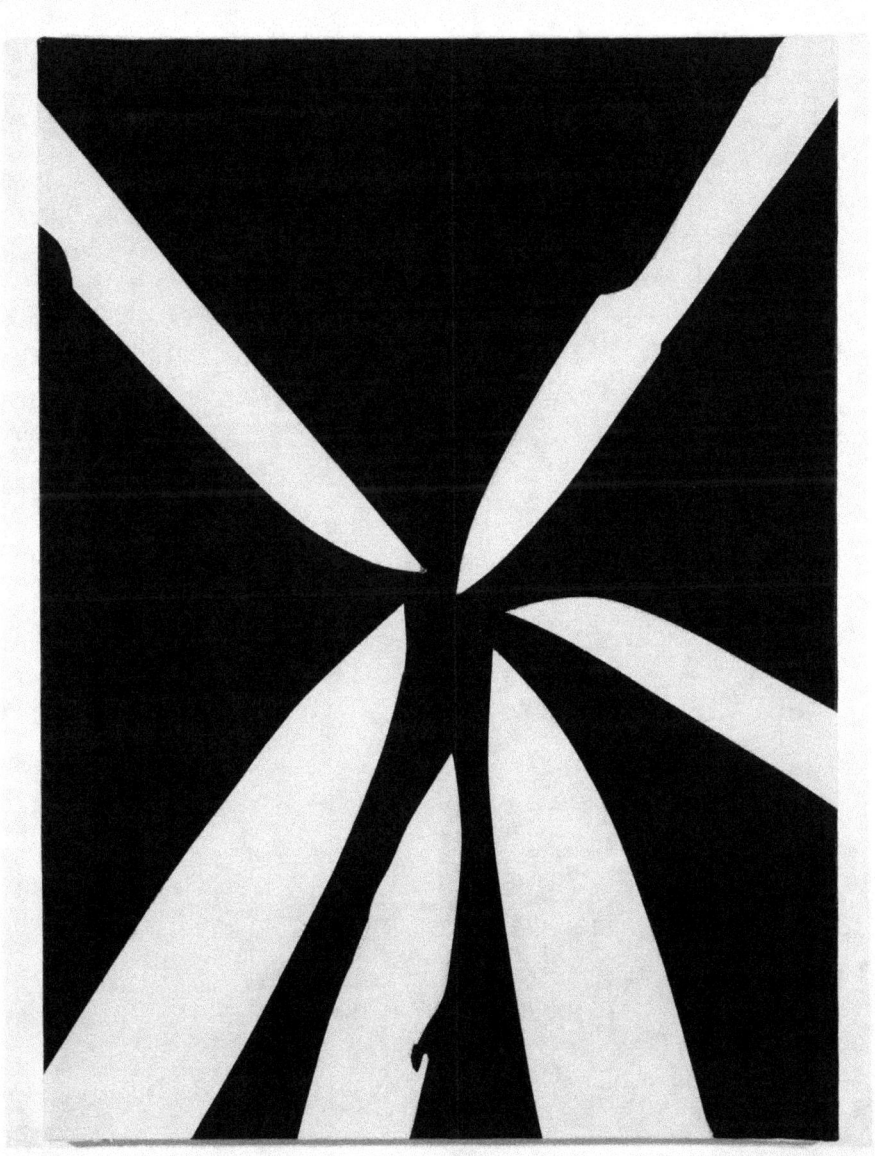

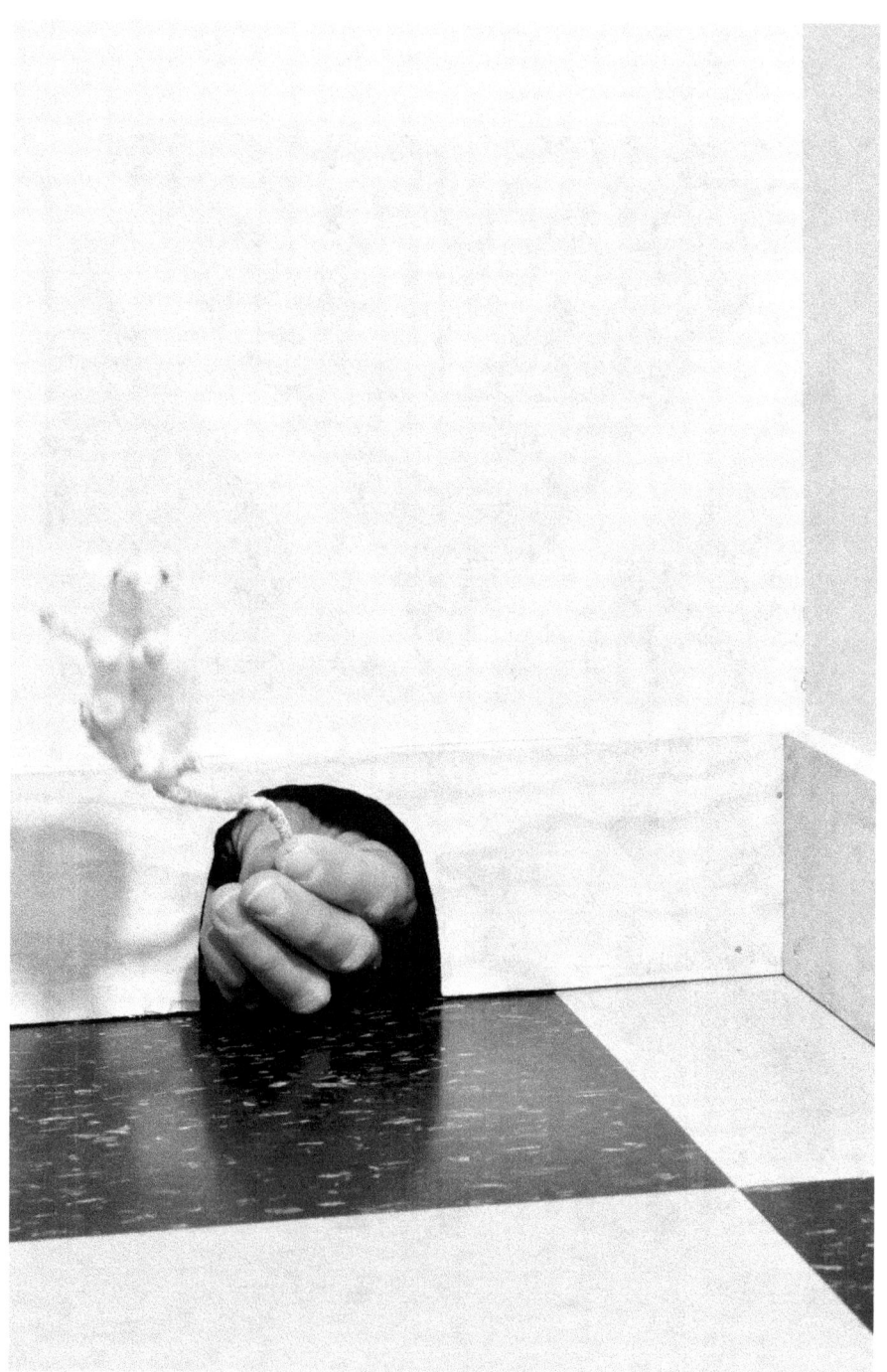

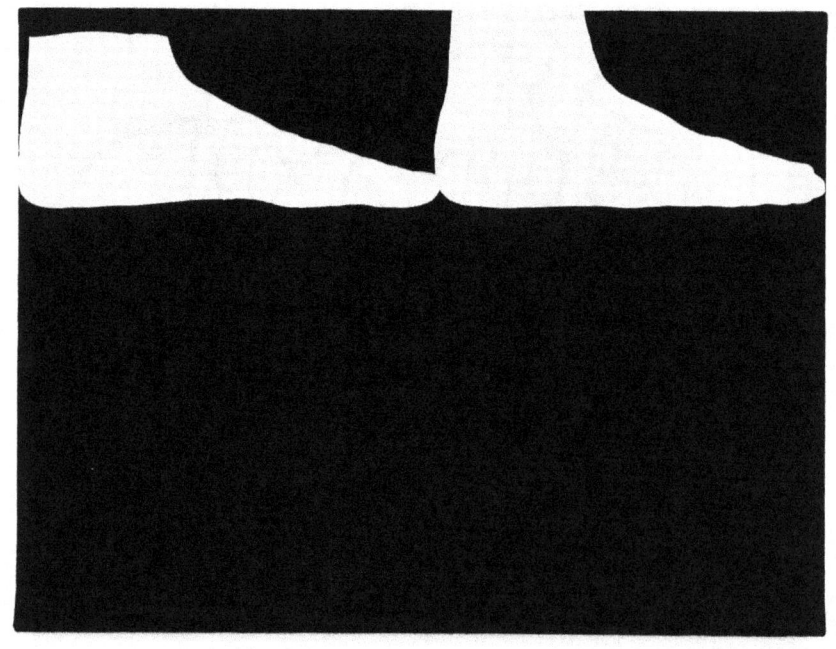

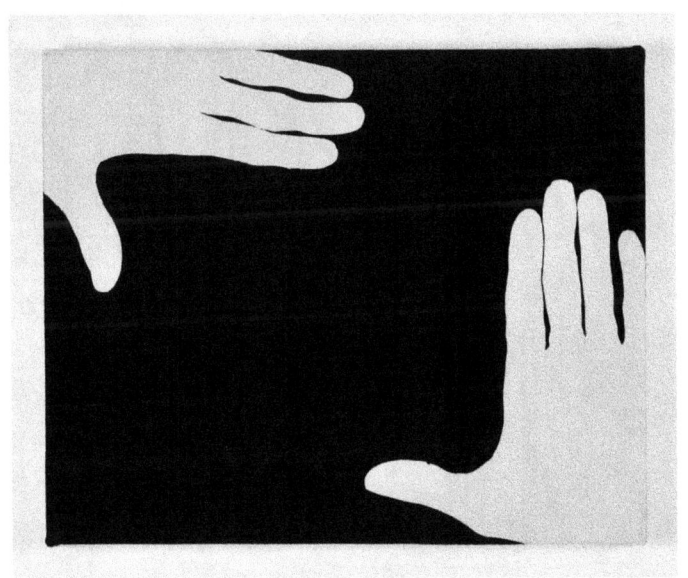

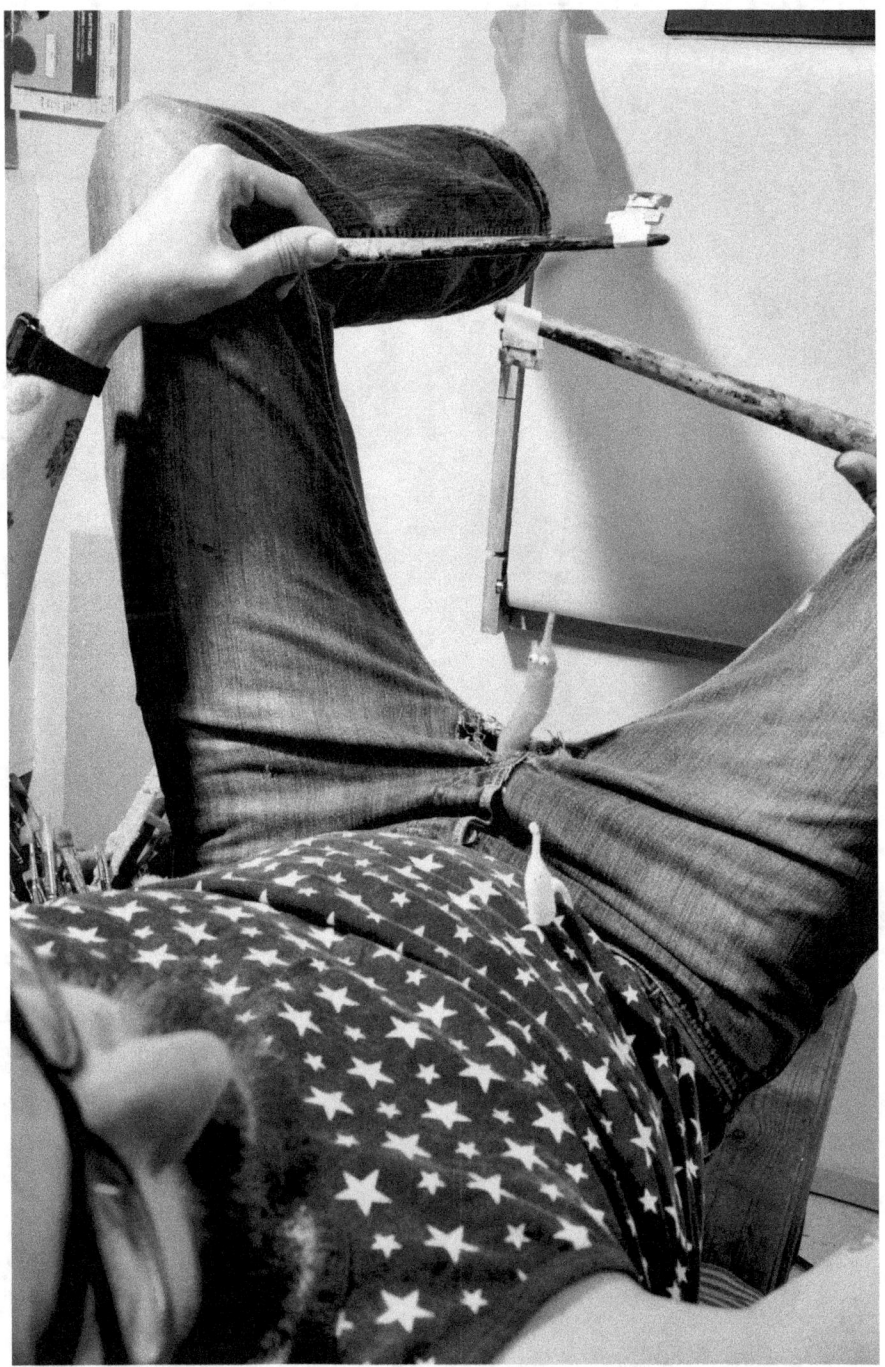

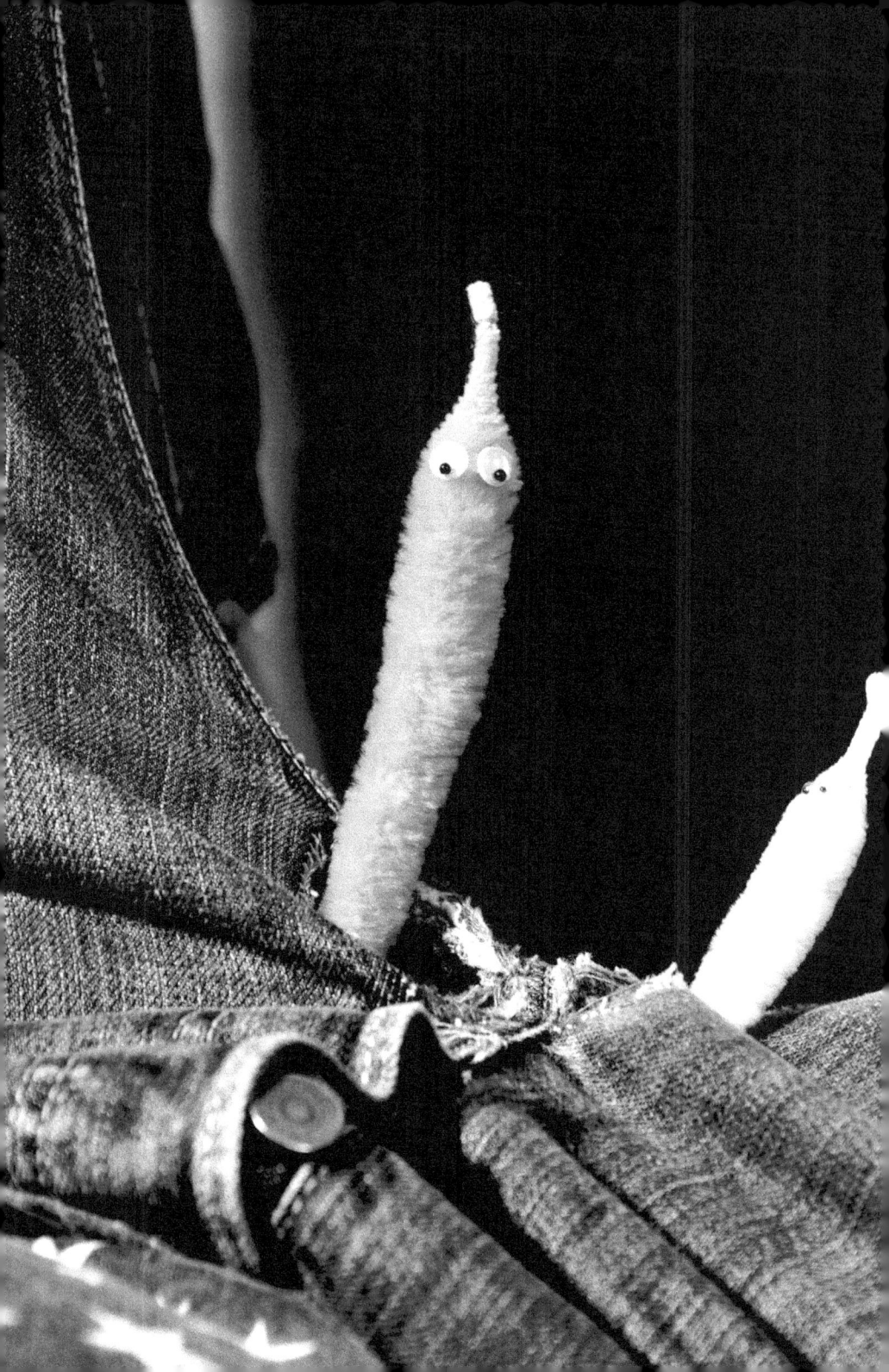

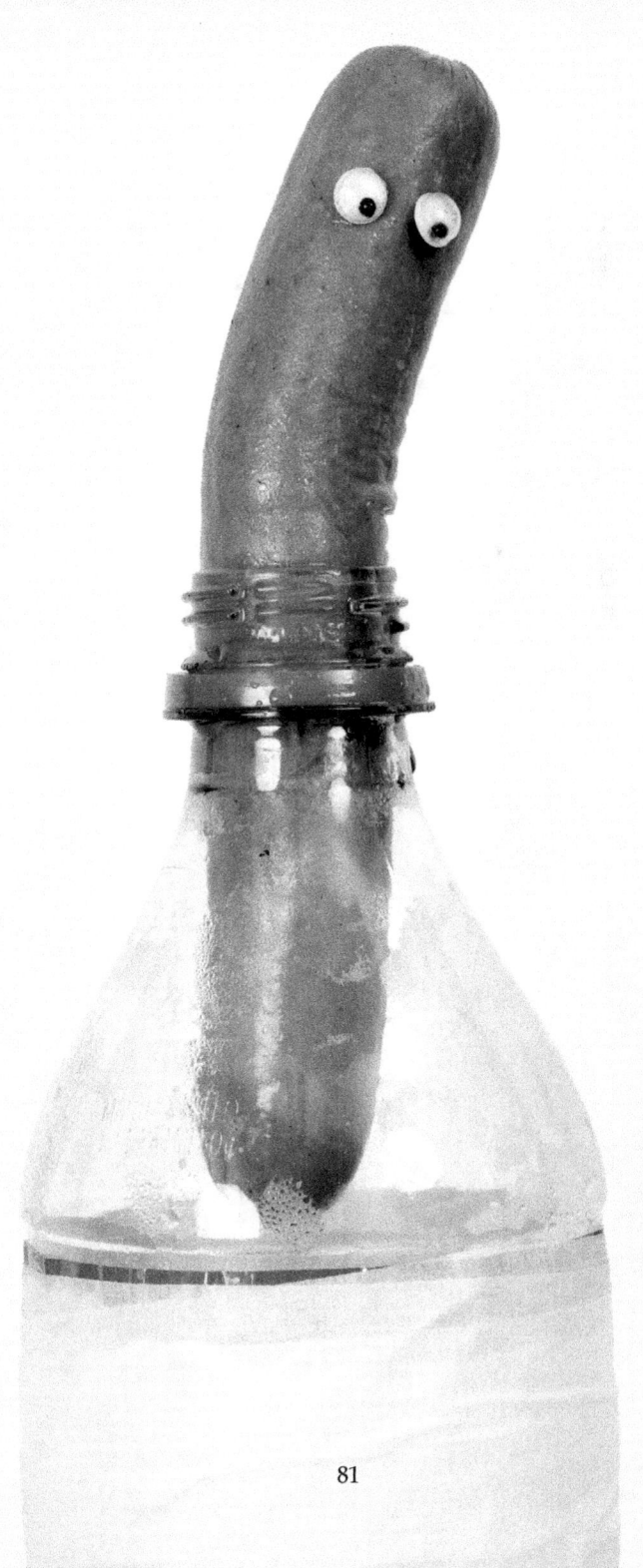

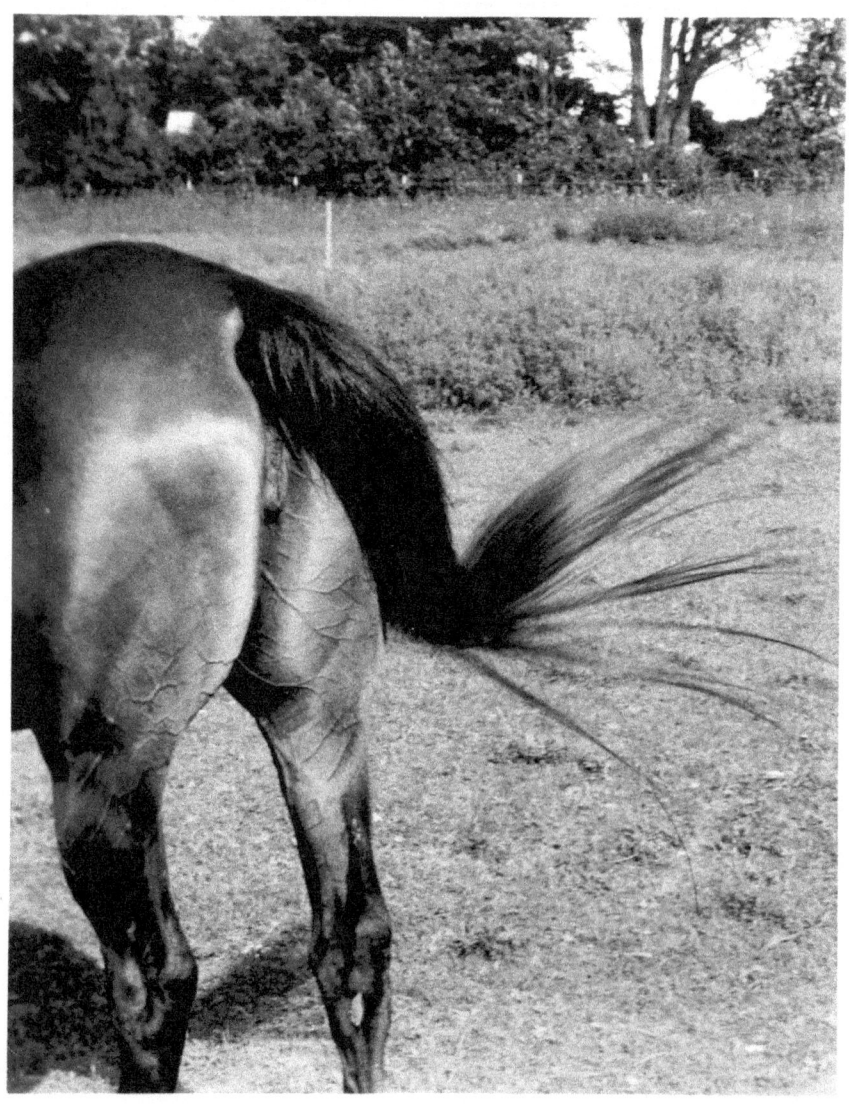

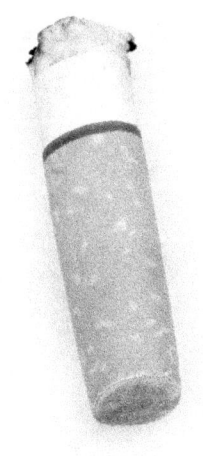

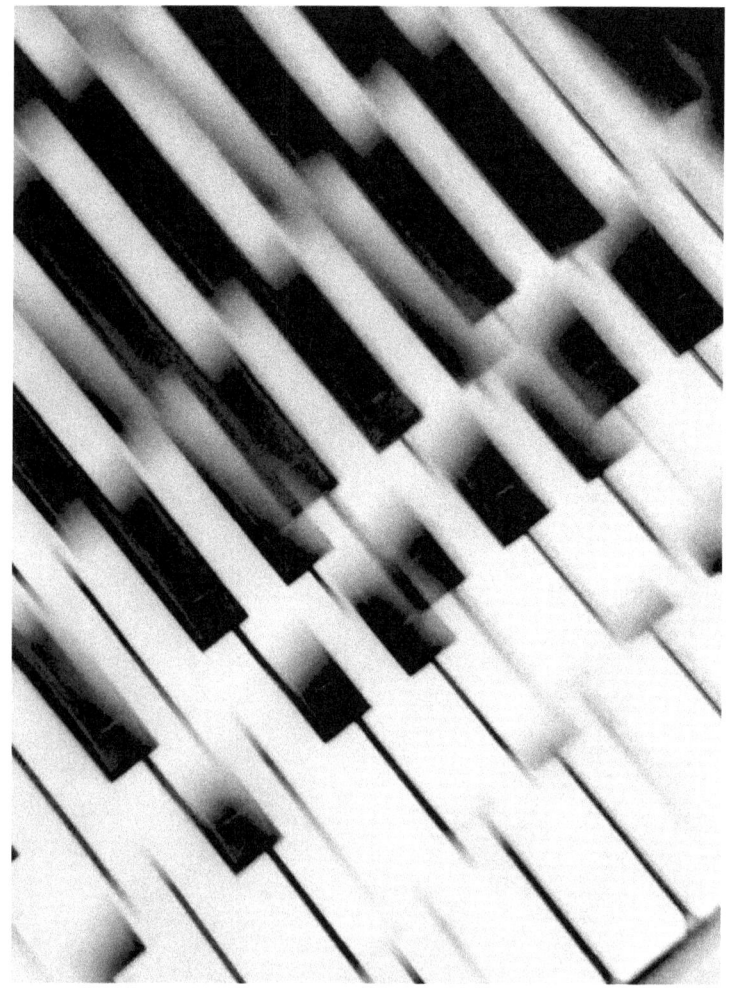

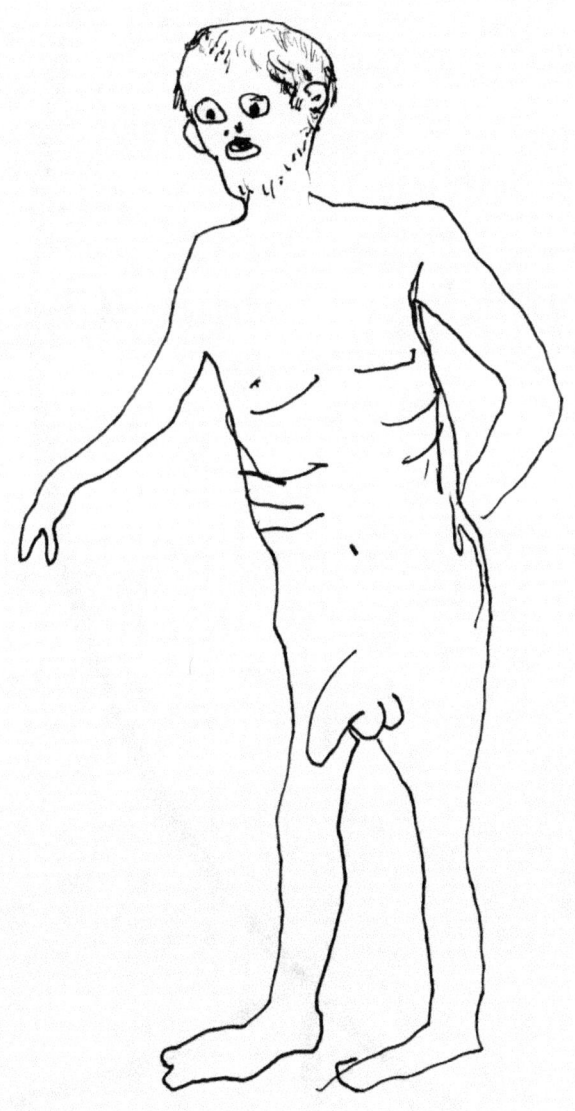

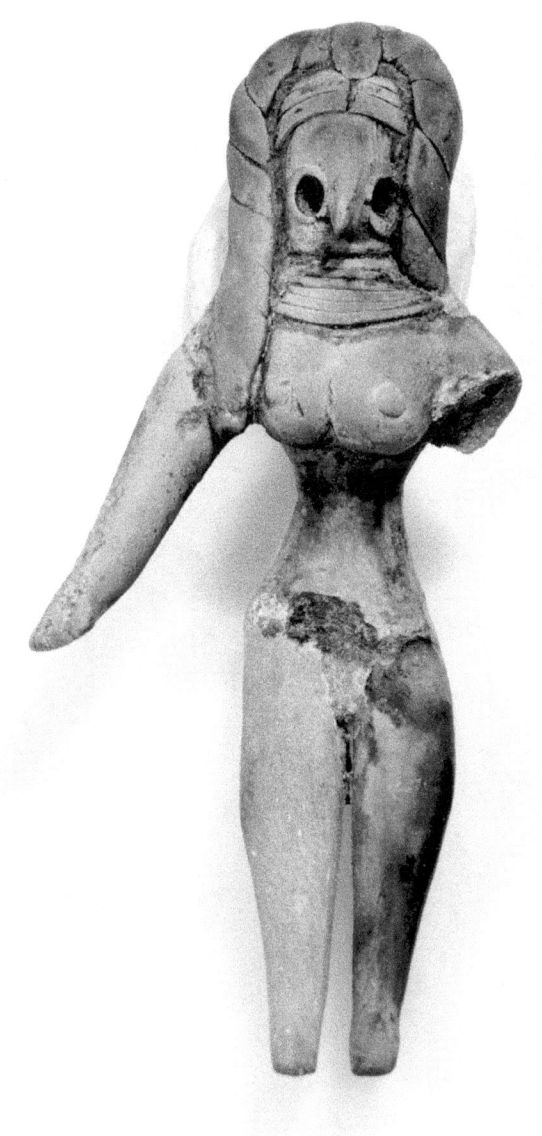

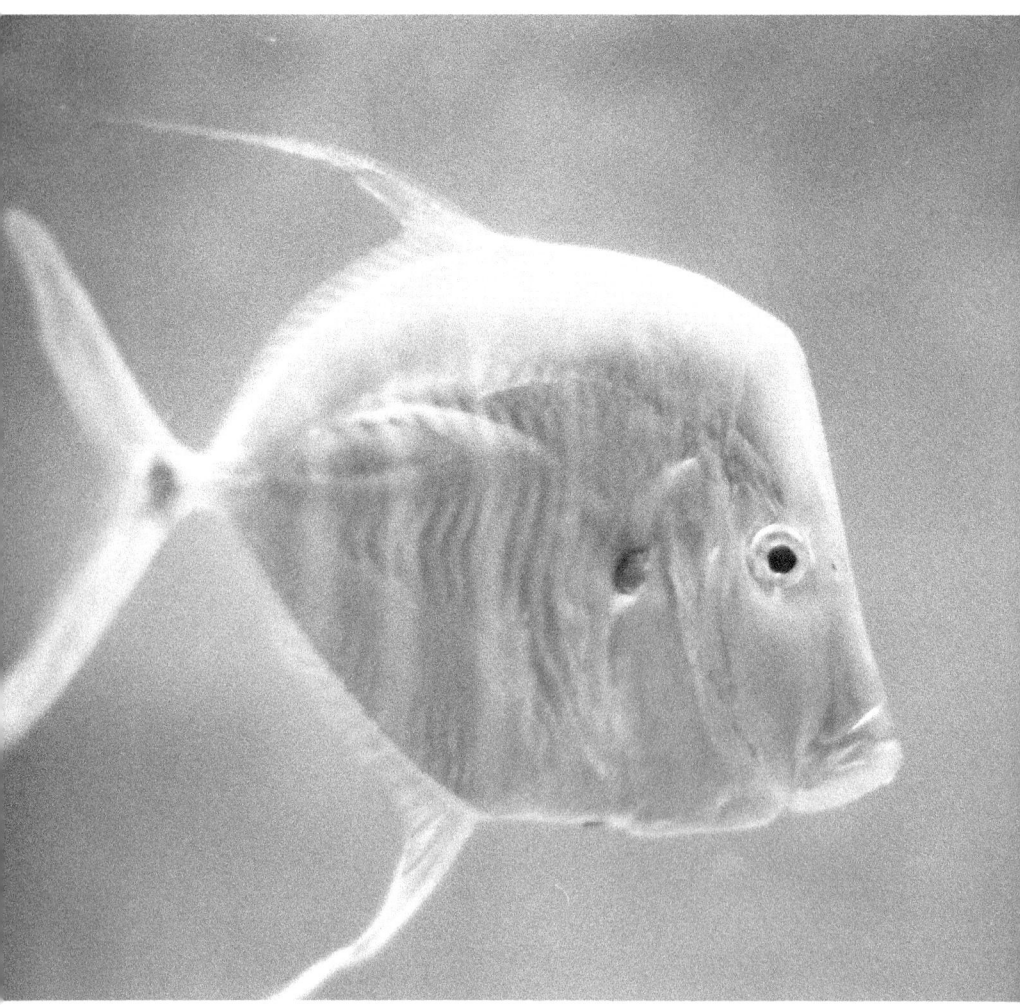

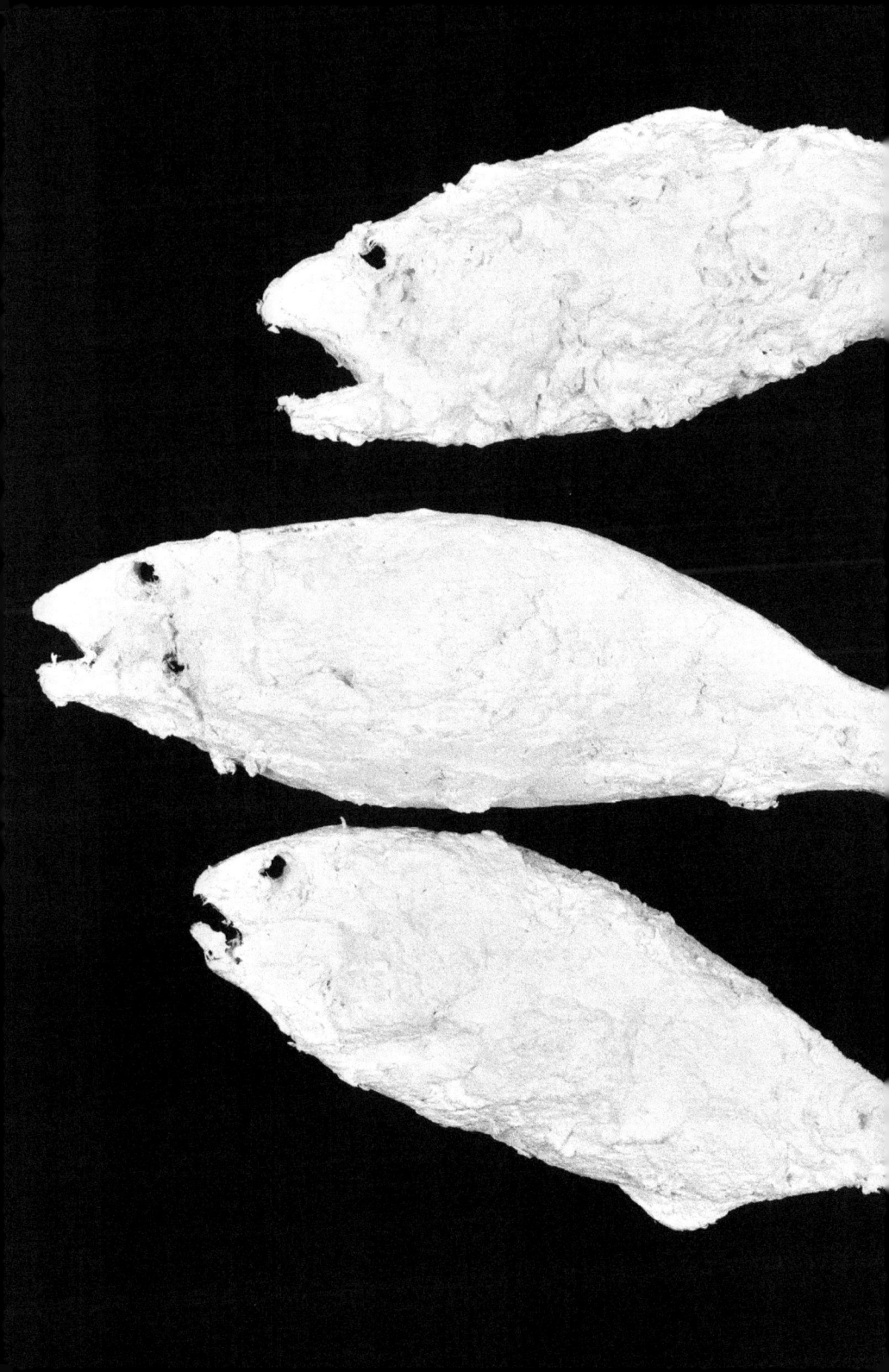

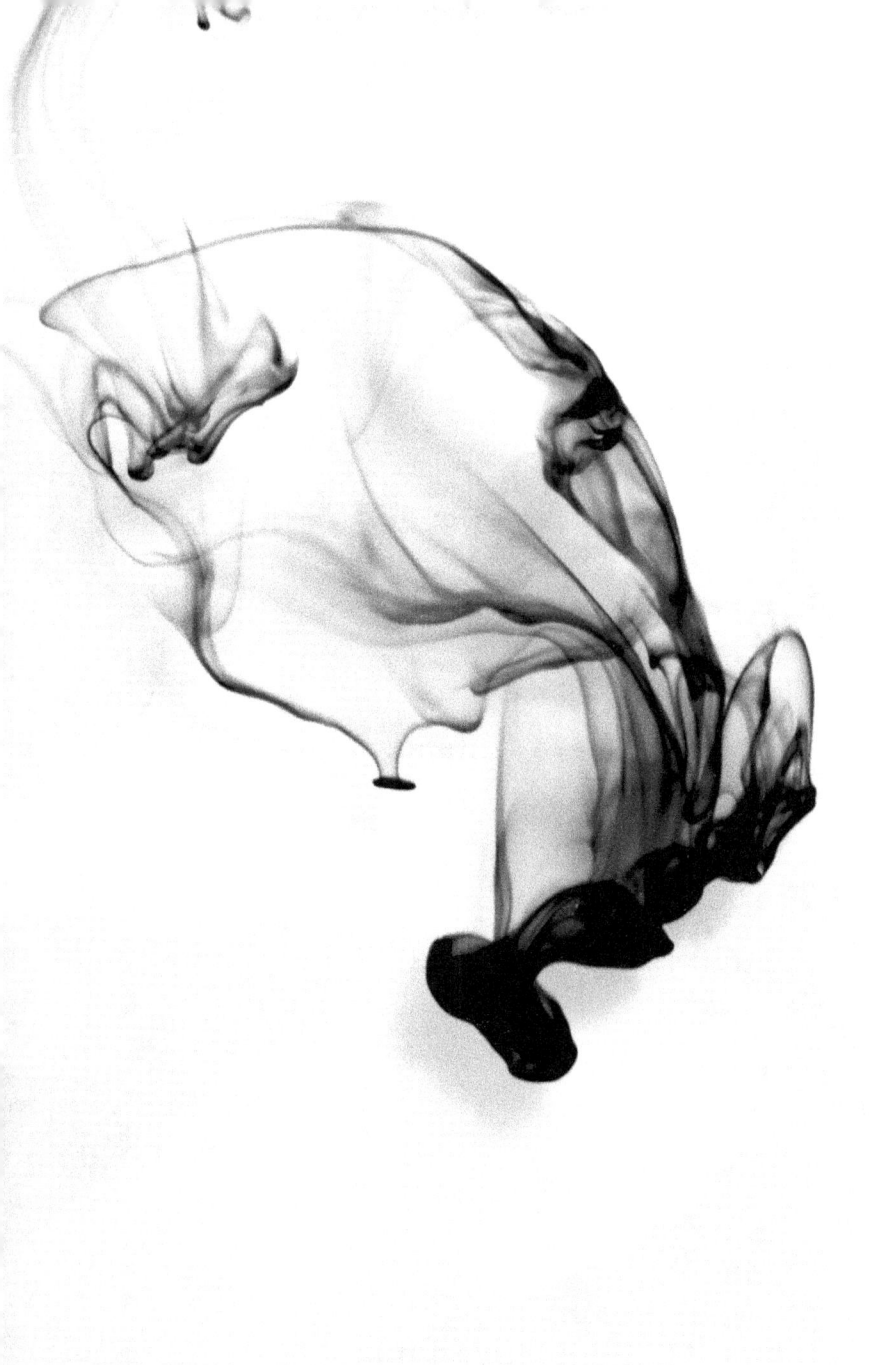

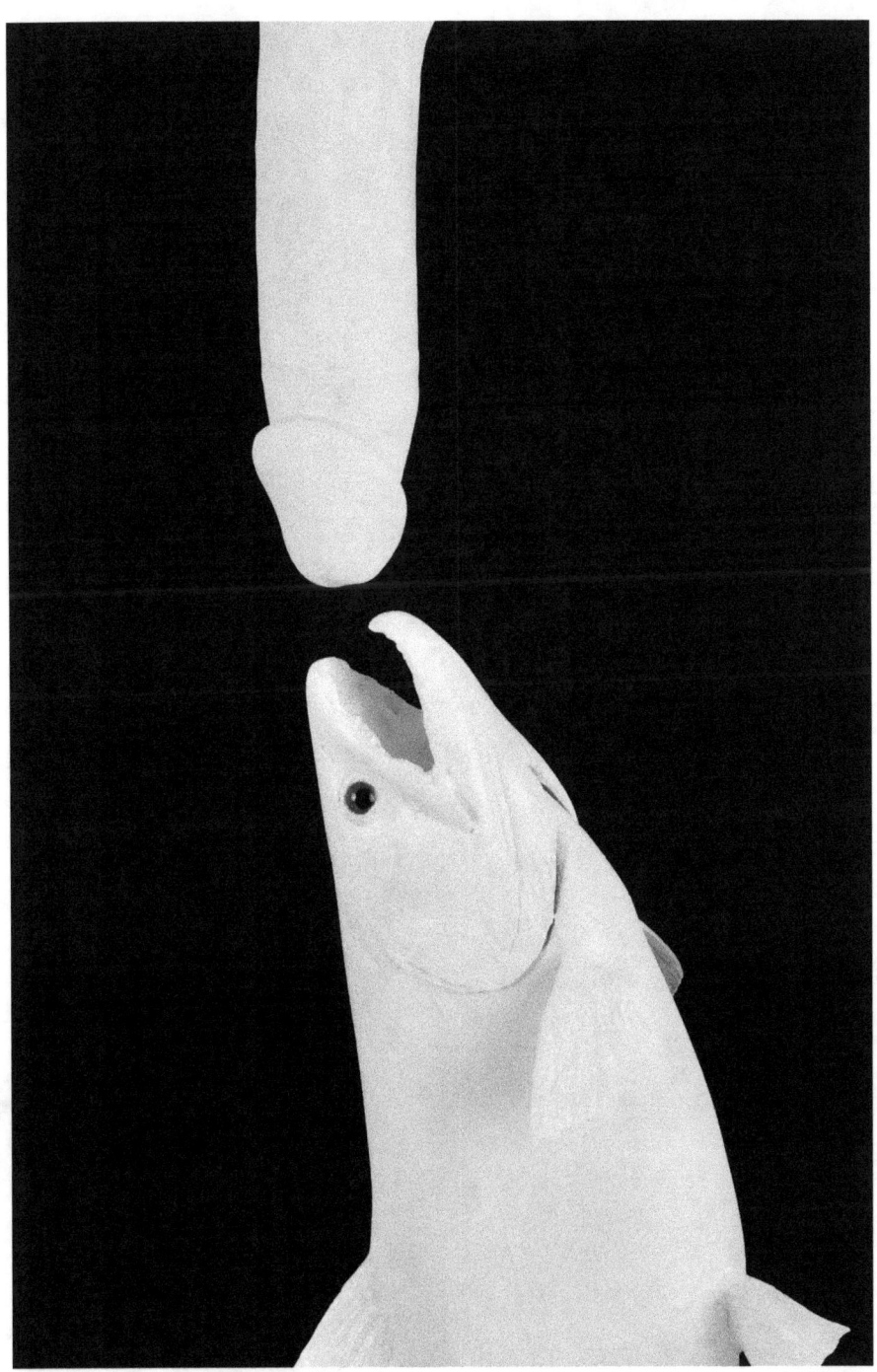

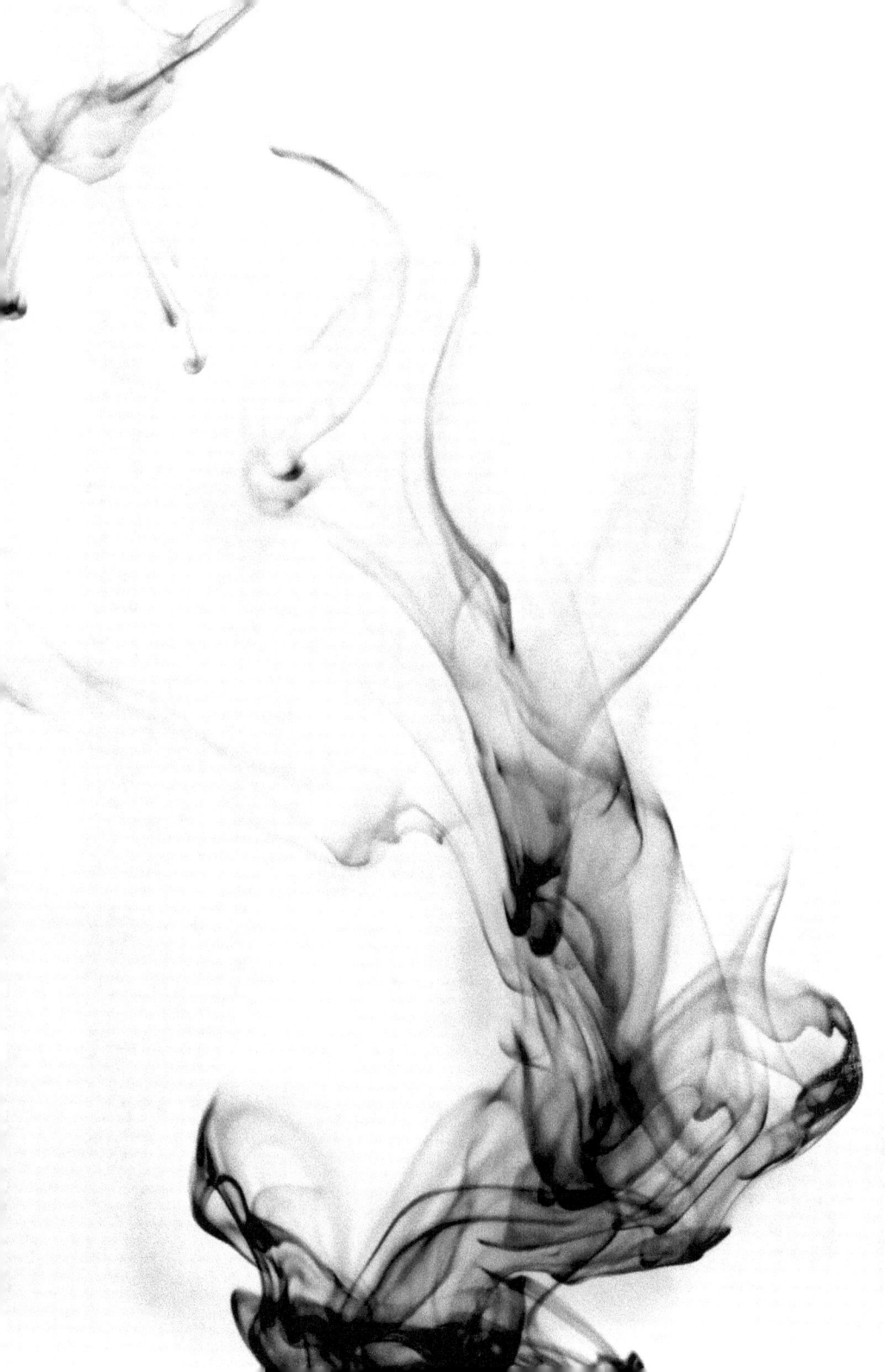

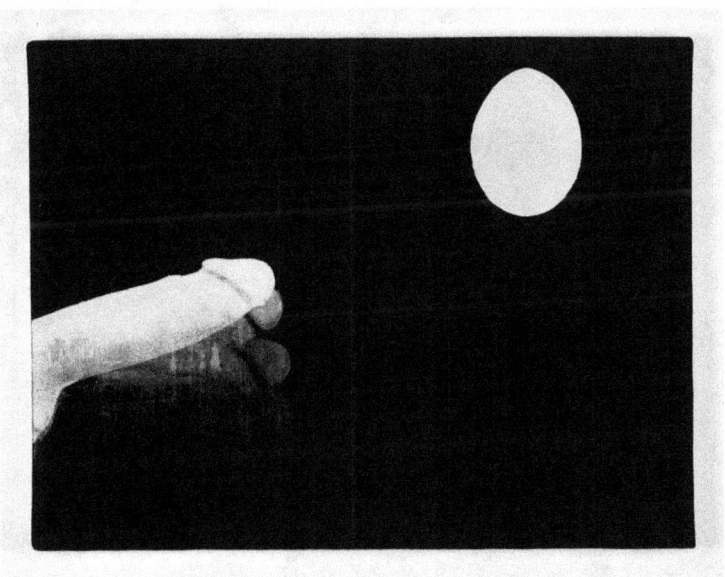

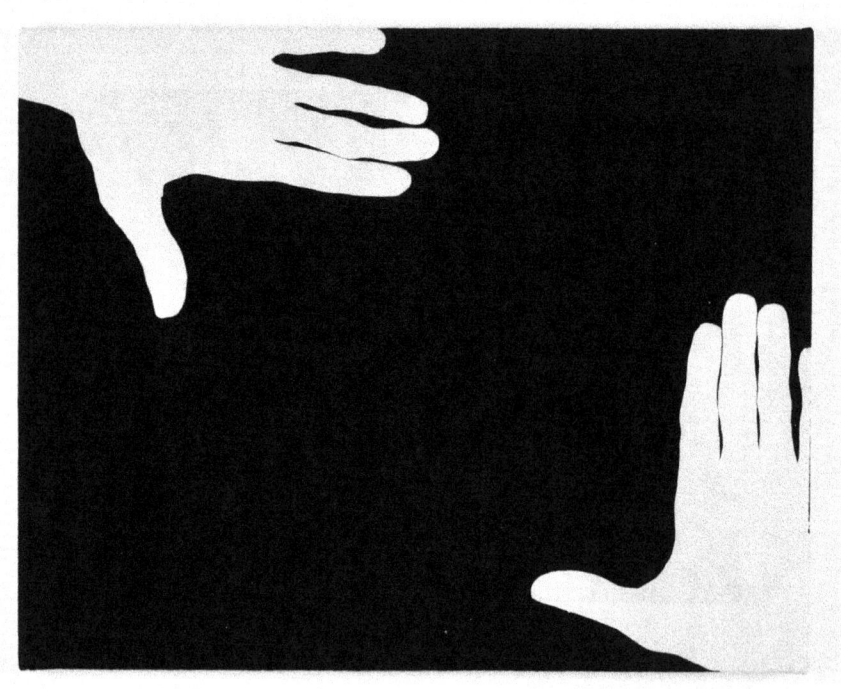

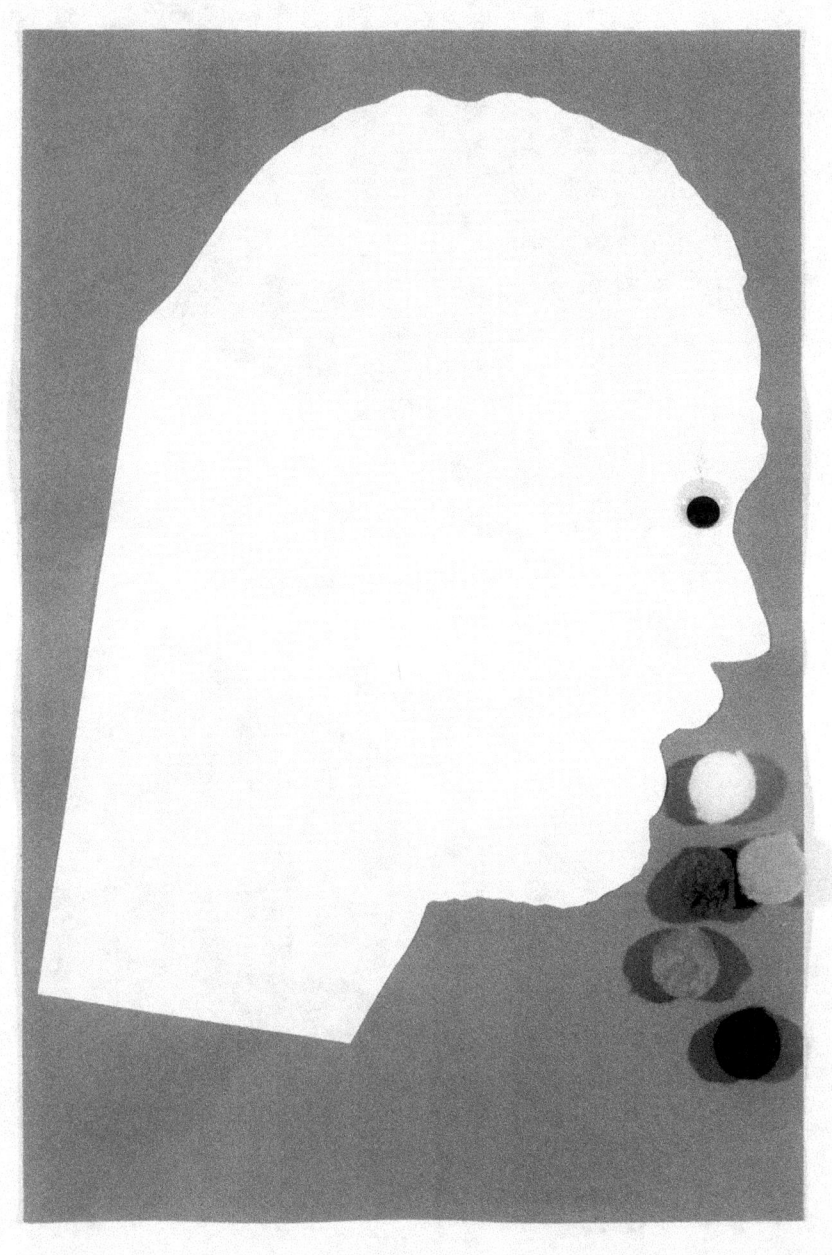

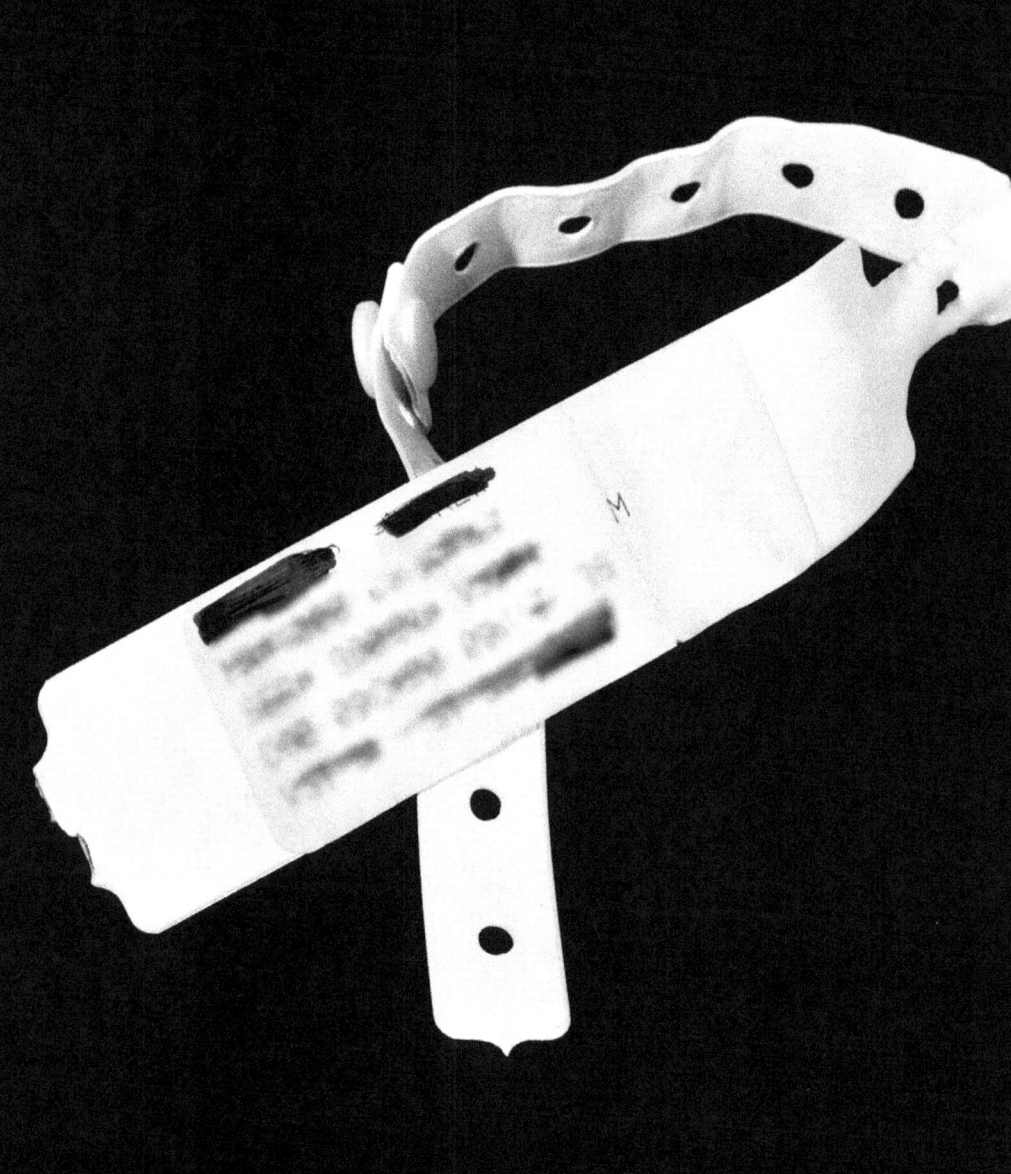

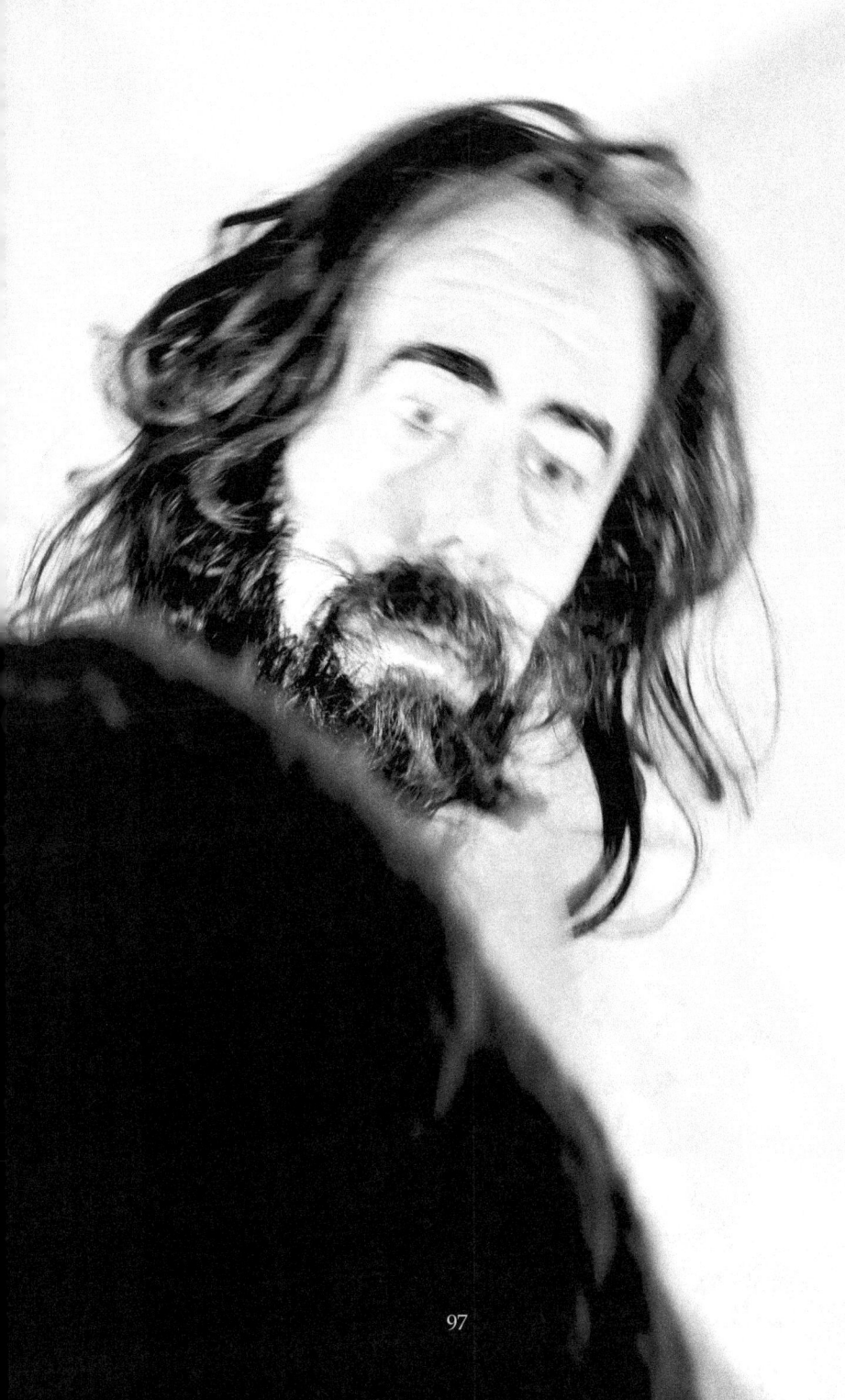

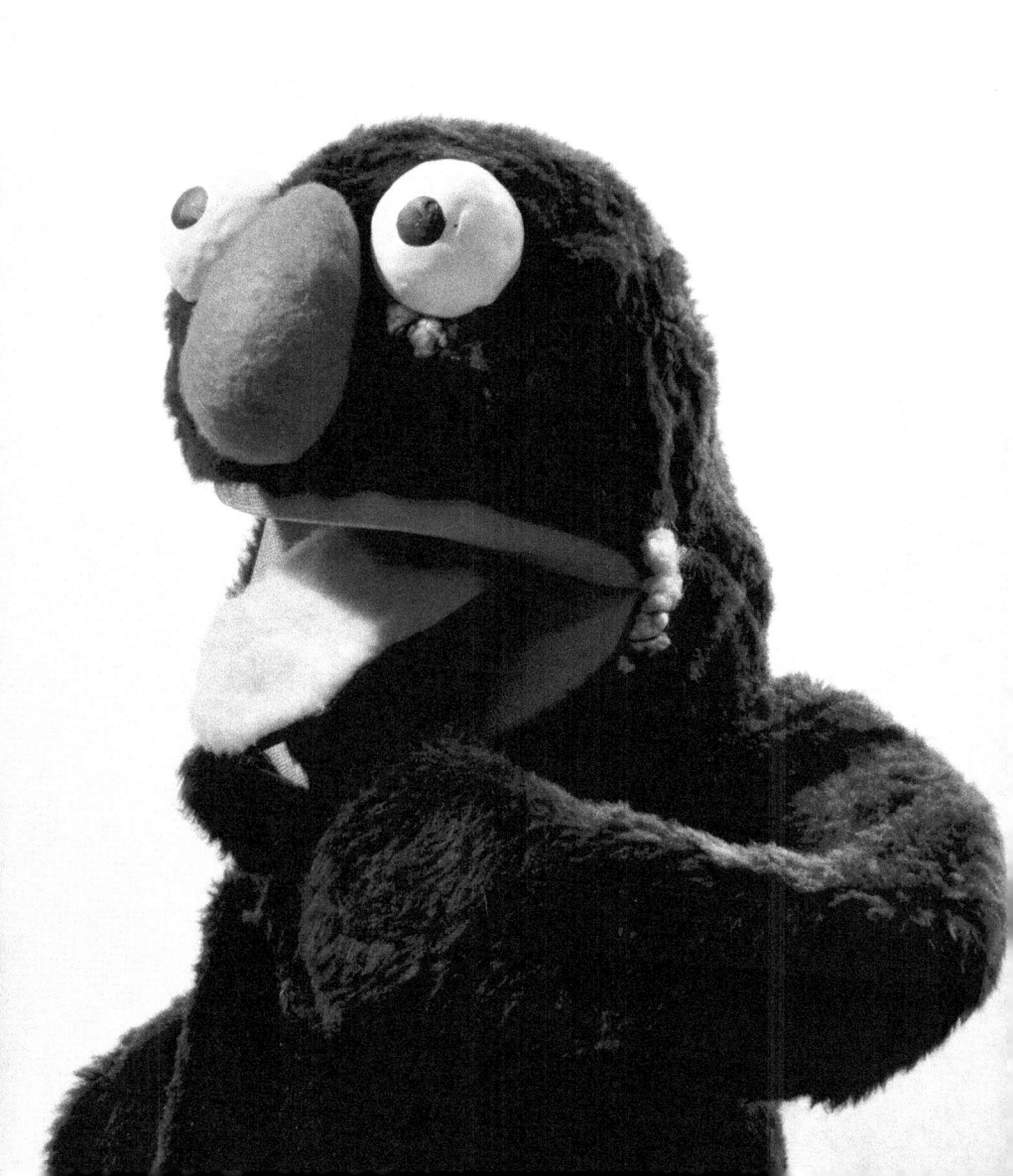

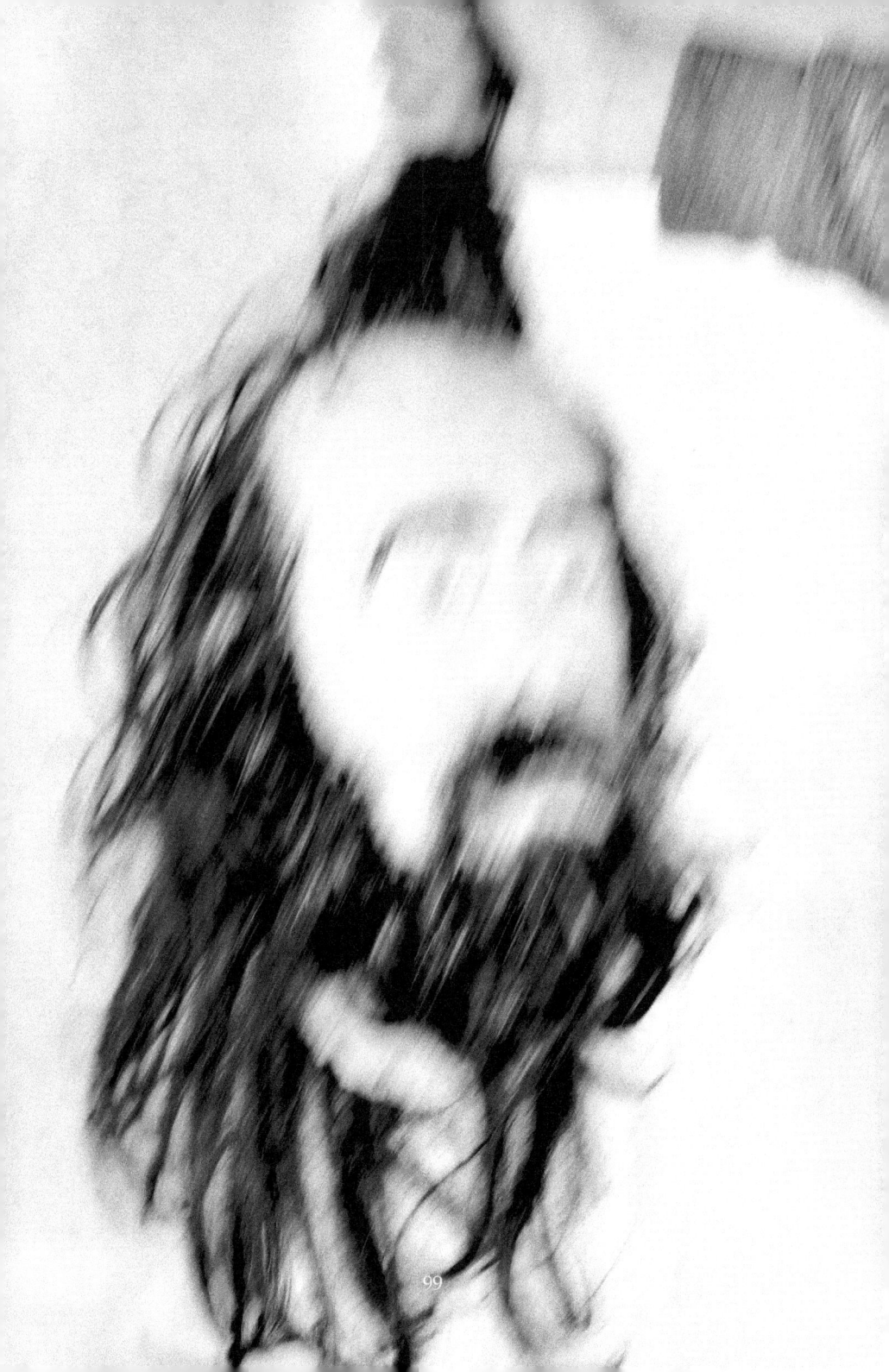

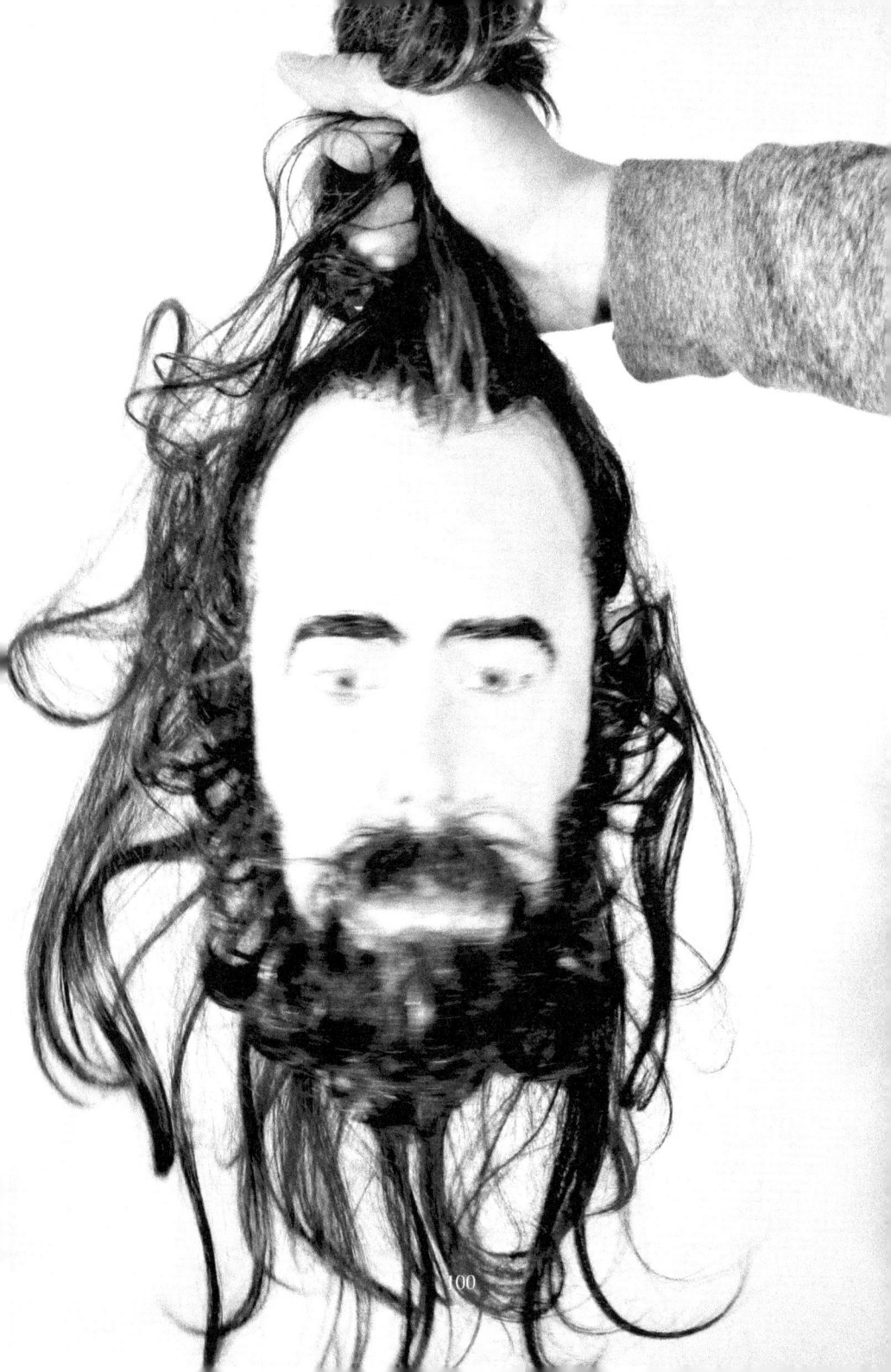

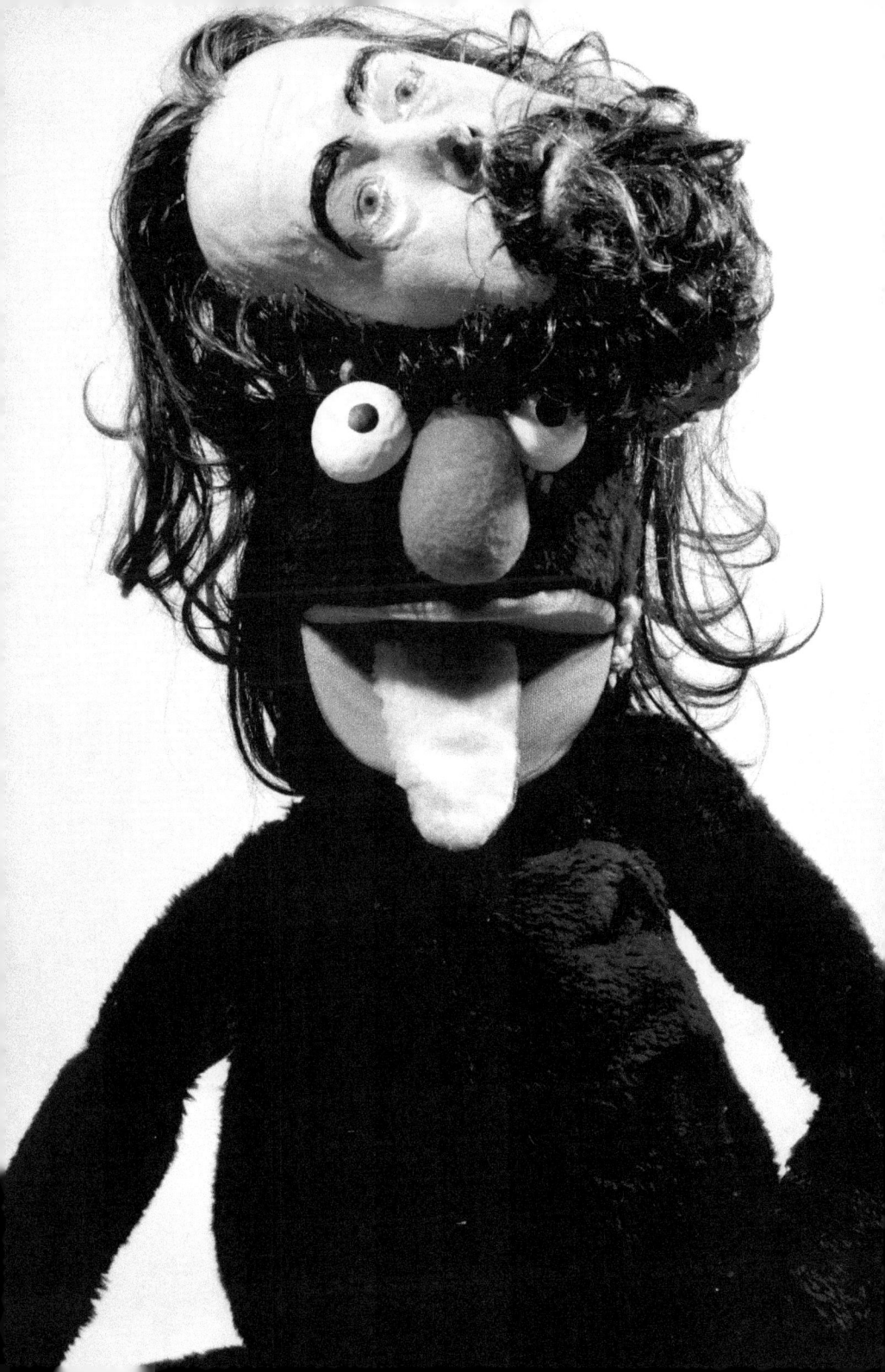

List of Illustrations

p. 8 *Table II*, 2013, plaster, wood, ceramic, candle, and metal on canvas, 24 x 23 x 8.5 in.
p. 10 *Relief*, 2013, wood and acrylic on panel, 24 x 20 x 2 in.
p. 11 *Two Floral Molds*, 2014, photograph
p. 12 *Bag*, 2013, photograph
p. 13 *Chewing Gum*, 2013, photograph
p. 14 *Wooden Box*, 2014, photograph
p. 15 *Stretched Cube*, 2013, wood, acrylic and canvas on panel, 18 x 24 in.
p. 16 *Page from notebook*, 2013
p. 17 *One*, 2013, acrylic on canvas, 12 x 16 in.
p. 18 *Page from notebook*, 2013
p. 19 *Where Two Sounds Meet*, 2013, acrylic on canvas, 12 x 16 in.
p. 20 *Hotdog in a Banana Costume*, 2014, photograph
p. 21 *Pink Noise*, 2013, acrylic on canvas, 12 x 16 in.
p. 22 *A Laughing Room, page from notebook*, 2013
p. 23 *Curved Walls*, 2013, acrylic on canvas, 12 x 16 in.
p. 24 *Diamond Cubes*, 2013, acrylic and canvas on panel, 18 x 24 in.
p. 25 *Soda Can*, 2014, photograph
p. 26 *Empty Glass*, 2014, photograph
p. 27 *Three*, 2013, acrylic on canvas, 18 x 24 in.
p. 28 *Four*, 2013, acrylic on canvas, 18 x 24 in.
p. 29 *Bread Reflection*, 2013, photograph
p. 30 *Five*, 2013, acrylic on canvas, 18 x 24 in.
p. 31 *Thumb*, 2013, photograph
p. 32 *Gesture*, 2013, acrylic on canvas, 70 x 50 in.
p. 33 *Eight*, 2013, acrylic on canvas, 18 x 24 in.
p. 34 *Blurred Trace*, 2013, acrylic and canvas on panel, 18 x 14 in.
p. 35 *Jerry's Missing Finger*, 2014, photograph
p. 36 *Dissolver*, 2013, acrylic on canvas, 30 x 24 in.
p. 37 *Square Arrangements, page from notebook*, 2013
p. 38 *To Give Life Part I*, 2014, photograph
p. 39 *Study on Accelerants*, 2013, acrylic on canvas, 12 x 16 in. (top), *Study on Disorder*, 2013, acrylic on canvas, 12 x 16 in. (bottom)
p. 40 *To Give Life Part II*, 2014, photograph
p. 41 *Aversion to Order*, 2013, acrylic on canvas, 18 x 24 in.
p. 42 *To Give Life Part III*, 2014, photograph
p. 43 *Influence of Disorder*, 2013, acrylic on canvas, 18 x 24 in.
p. 44 *To Give Life Part IV*, 2014, photograph
p. 45 *Recording Order*, 2013, acrylic on canvas, 18 x 24 in.
p. 46 *The Weight of an Idea*, 2014, photograph

p. 47 *Three-Quarter Pound of Shit*, 2014, photograph
p. 48 *Digital Display*, 2014, photograph
p. 49 *Eliminating Cat*, 2013, screen print on black paper, 6.25 x 8 in.
p. 50 *Spaces in Time*, 2013, acrylic on canvas, 18 x 24 in.
p. 51 *On Vacation*, 2011, photograph
p. 52 *Less than a Second*, 2013, acrylic on canvas, 18 x 24 in.
p. 53 *Silent Chime*, 2013, photograph
p. 54 *Mosquito at Rest*, 2012, photograph
p. 55 *Attempt to Organize*, 2013, acrylic on canvas, 18 x 27 in.
p. 56 *Path of a Decision*, 2013, acrylic on canvas, 34 x 34 in.
p. 57 *Actions in the Park*, 2013, screen print on black paper, 8 x 6.25 in.
p. 58 *Chipped Glass*, 2014, photograph
p. 59 *Dissolution*, 2013, acrylic on canvas, 18 x 24 in.
p. 60 *An Immeasurable Weight (part A)*, 2013, photograph
p. 61 *An Immeasurable Weight (part B)*, 2013, photograph
p. 62 *Pod Agreement*, 2013, ink on paper, 11.75 x 9 in.
p. 63 *Ultra Deep Field*, 2013, acrylic on canvas, 50 x 40 in.
p. 64 *Soft Light*, 2012, photograph
p. 65 *Popcorn Noise I*, 2013, acrylic on canvas, 18 x 24 in.
p. 66 *Object Arrangement*, 2014, photograph
p. 67 *Popcorn Noise II*, 2013, acrylic on canvas, 18 x 24 in.
p. 68 *Illustrating the Spirit*, 2014, photograph
p. 69 *Popcorn Noise III*, 2013, acrylic on canvas, 18 x 24 in.
p. 70 *Popcorn Illusions*, 2013, photograph
p. 71 *Arpeggio*, 2014, photograph
p. 72 *Atonic*, 2014, photograph
p. 73 *Six Knives*, 2013, acrylic on canvas, 24 x 18 in.
p. 74 *Behind Walls*, 2014 photograph
p. 75 *The Wurst Idea*, page from notebook, 2012
p. 76 *Two Feet*, 2013, acrylic on canvas, 18 x 24 in.
p. 77 *The Auteur II*, 2013, acrylic on canvas, 11 x 14 in.
p. 78 *Study for The Auteur*, page from notebook, 2013
p. 79 *Production Still*, 2013, photograph
p. 80 *Emerging Worms*, 2013, photograph
p. 81 *On Space Travel*, 2014, photograph
p. 82 *Horse*, 2010, photograph, 10 x 8 in.
p. 83 *Cigarette*, 2014, photograph
p. 84 *Kaleidoscope Keys*, 2014, photograph
p. 85 *The Bather*, page from notebook, 2013
p. 86 *Butt*, page from notebook, 2014

p. 87 *Female Figure*, 2014, photograph
p. 88 *Fish*, 2010, photograph
p. 89 *School*, 2014, photograph
p. 90 *Smoke in the Water*, 2014, photograph
p. 91 *Night Bath*, 2013, photograph
p. 92 *Smoke in the Water II*, 2014, photograph
p. 93 *Egg*, 2013, acrylic on canvas, 12 x 16 in.
p. 94 *The Auteur*, 2013, acrylic on canvas, 14 x 18 in.
p. 95 *Silhouette*, 2013, cut paper, pom-poms, plastic eye, 18 x 12 in.
p. 96 *Hospital Visit*, 2014, production still
p. 97 *Hospital Magician*, 2014, production still
p. 98 *Consider the Options*, 2014, production still
p. 99 *The Magic Trick*, 2014, production still
p. 100 *The Reality*, 2014, production still
p. 101 *Recovery*, 2014, production still

www.ingramcontent.com/pod-product-compliance
Lightning Source LLC
Chambersburg PA
CBHW072222170526

45158CB00002BA/715